Denali
Early Photographs of Our National Parks

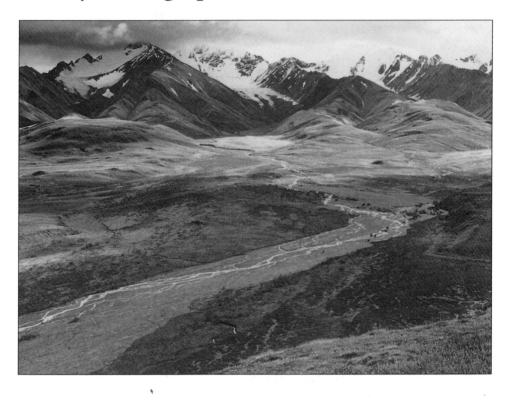

Jane Haigh

For Don, Patsy + Ian;
From Out of the North
Jane Haigh
Anchorage
2000

Digital Pre-Press by
 Joel Edgecombe
Edited by Ann
 Chandonnet
Copy Edited by Clélie
 Rich, Rich Words Editing
 Services, Vancouver, BC
Design and Production by
 Wolf Creek Books Inc.
Printed and Bound in
 Canada

Canadian Cataloguing in Publication Data

Haigh, Jane -
Denali
Early Photographs of Our National Parks

Includes index.
ISBN 0-9681955-7-1

Acknowledgements

This book is the result of the skill and support of many people. The author wishes to thank Rene Blahuta for being supportive from the beginning, Jane Bryant and Jennifer Wolk at Denali National Park, the staff at University of Alaska Fairbanks Archives, Diane Brenner at AMHA-Denali Foundation, and Denali Backcountry Lodge.

WOLF CREEK BOOKS INC

Box 31275,
211 Main Street,
Whitehorse, Yukon
Y1A 5P7
info@wolfcreek.ca
www.wolfcreek.ca

CONTENTS

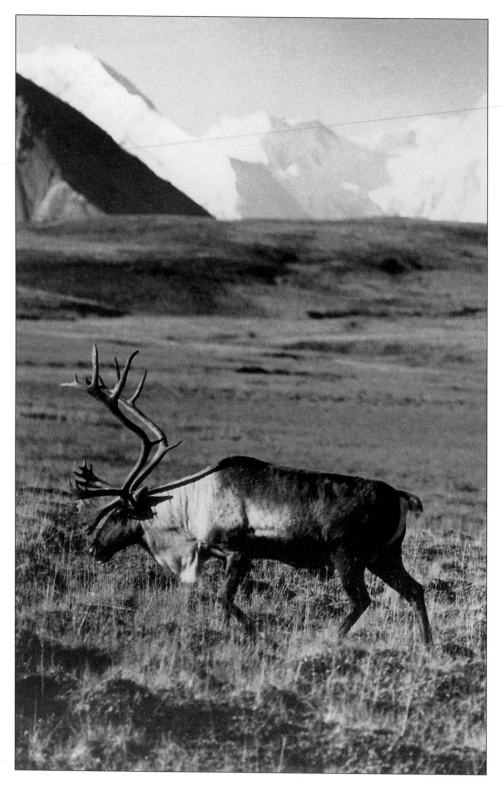

THE GREAT WILDERNESS

"Mt. McKinley;" the name became an icon, symbolizing all that was remote, austere, unchallenged, pure.

The name Mt. McKinley was attached to the tallest mountain in North America in 1896 by William A. Dickey, a Princeton-educated prospector with New York newspaper connections. It was by this name that it was known during the period of its initial discovery by the American public, and its subsequent exploration. It was as Mt. McKinley that the great northern massif with its cascading glaciers affected the American imagination and came to embody remoteness and mystery. Even so, those who were attracted by this image and came to explore the mountain came to agree that it had been, was, and should be for all time, called Denali.

In looking backward over the history of the big mountain, it seems strange and unfortunate that the name of McKinley should have been attached to it. Any of the Indian names, or the Russian name of Bulshaia, would have been far more appropriate historically as well as sentimentally, while if any proper name was used it should have been Densmore, the old pioneer whose vivid word pictures of the mountain's grandeur made it known to the old-time prospectors along the Yukon. Belmore Browne

Caribou Bull in the heart of the high valleys in Denali National Park.

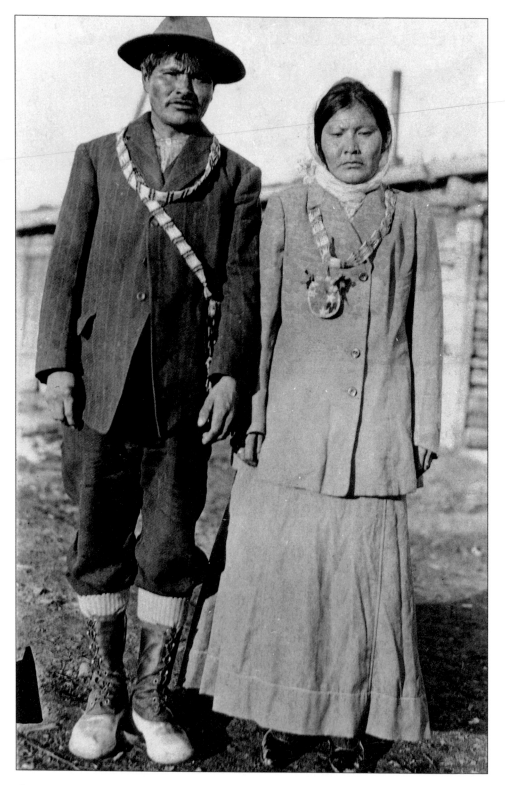

PEOPLE OF THE RIVER

Although at the beginning of the 20th century Alaska's Interior seemed remote to explorers east of the Rockies, it was not, in fact, an empty wilderness. Denali was part of the home territories of several Athabascan groups who call themselves collectively the Dena—the people. While anthropologists link the Athabascans to the Navajo of the southwest, and archaeologists have found sites near Denali as old as 12,000 years, the Athabascans themselves believe that the Dena were placed in Alaska by an act of creation and have been in the Interior since First Time.

The Athabascans live a semi-nomadic life as hunter gatherers in villages and camps, in small bands or family groups. To the south are the Denaina or Tanaina, living on the shores of Cook Inlet, on the Alaska Peninsula, the Kenai Peninsula and in the valleys of the Matanuska and Susitna Rivers. To the east, the Ahtna inhabited the Copper River Valley and hunted the area traversed in modern times by the Denali Highway and into Denali's eastern foothills. To the southwest and west, the Dena settled in the valley of the Upper Kuskokwim River and began to hunt, fish and trap further north through the broad plains at its headwaters. To the northwest the Koyukon live on the mighty Yukon from Nulato to Tanana. They hunted and trapped in the flats and streams south of the great river. To the north, the Tanana people of the Lower Tanana River maintained villages and seasonal camps from Salchaket and Chena to Wood River, Tolchaket, Cos Jacket, Minto and Tolovana.

Climb to the top of Wickersham Dome in the Kantishna Hills and look out. Below to the northwest is a hazy, flat plain, vast as an ocean. The flats of the Tanana and Lake Minchumina join with the headwaters of the Kuskokwim to form a trade route in use for thousands of years. Furs from the Interior were traded for seal and whale blubber, dentalia shells, and even trade goods from Siberia which found their way into Alaska via Siberian Eskimos even before Russian settlement.

This fertile area, full of game, has been used in historic times over the past two centuries by three different Athabascan lin-

Roosevelt John and wife, 1919. Roosevelt John lived at the mouth of Birch Creek during the last several decades of his life. He ran a trapline on the east side of the McKinley River. His brother's daughter, Abbie Joseph, who lived in Tanana, participated in an extensive project to record the Native place names in the Kantishna area.

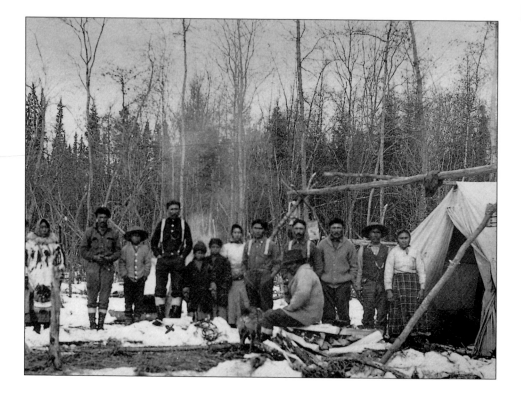

guistic groups. People of the Kuskokwim River moved up to the game-rich lakes and twisting streams. Lower Tanana people migrated from their camps on the Salcha, Toghotthele, Cos Jacket, and Wood Rivers to the Kantishna and the Muddy River to Lake Minchumina. Koyukon people were also expanding their territory, taking long hunting trips from Nulato, Koyukuk and Tanana into the upper reaches of the same watershed.

The Dena were chiefly an inland people. Traditionally they fished the river valleys, trapped near lakes and streams, and coursed over the foothills and tundra after caribou, moose and sheep. They also carried on trade with one another. Operating in extended family groups or bands of about 50, they moved seasonally. In the fall they might occupy larger camps or villages on the Yukon or Tanana, the Susitna or Kuskokwim, netting or trapping salmon and drying it. Then the hunters would depart for the high hills to hunt caribou. Later, smaller family units would canoe or hike up the minor rivers and streams to establish winter trap lines for wolf, marten and fox. Late in the spring, "ratting"—trapping muskrat—would commence while there was still ice on the small lakes.

Above: Chief Dearfan and his tribe of about 50 lived principally at the old village of Telida on the winter trail between Nenana and McGrath. Chief Dearfan, fourth from left, Chief Sesui second from right with his wife.

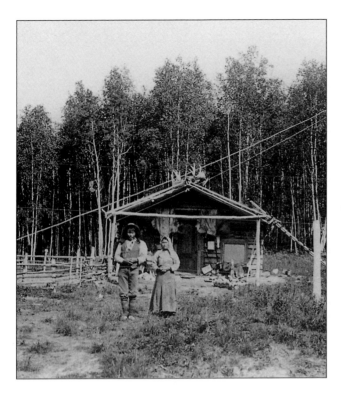

These old people have lived here all their lives and do not speak English.
Subsist on what fish they catch and the game they kill, eating very little of white man's grub, and using very little of his clothing, getting most of their clothing from moose and caribou skins and the pelts of fur animals.
Stephen Foster

Above: Andrew and his wife near Lake Minchumina.

When the ice broke and smaller rivers began to run, families loaded furs and meat harvested during winter into moose-skin boats and floated back down to the Yukon or Tanana, the Susitna, or the Kuskokwim. There on gravel river bars they joyously met friends and extended family. Visiting and feasting took place while the group waited for the dynamic break-up of the Yukon in mid-May.

When the first Russians began to penetrate Alaska's Interior in the early 1800s, the area of the upper Cos Jacket and upper Kantishna Rivers was an area of overlapping use. Each group spoke its own language—mutually intelligible but distinct. The three groups intermarried over time, giving many modern residents of the area branches of family from all three groups.

Place names and the stories associated with them are part of the rich textile of Athabascan culture, providing threads that penetrate and provide insights into the natural and human histories of Interior Alaska. The naming of specific places also defines the area of use by specific groups and families. Many important features and places bear three distinct names in three distinct languages.

9

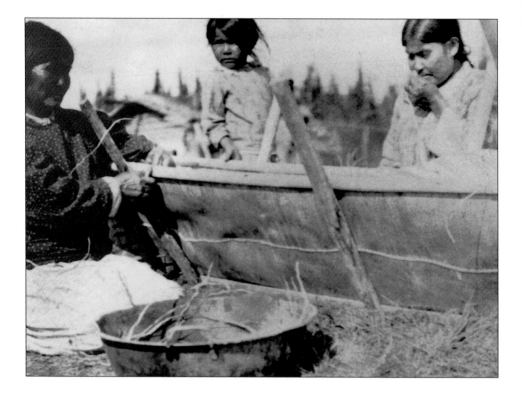

Olyman Chea is building a birch bark canoe. The ribs of
stout birch wood have been carefully shaped with his knife
and tied in place in the ways, with long tough spruce roots, to
longitudinal strips of clear, split spruce, thus preparing the
framework for the birch bark covering. The ways are built on
a dry and sandy spot on the bank of the river where the view
is pleasant the shade wide-spread and grateful.... The sheets
of birch bark are stripped from the living tree as the sap is
rising in the spring, and Olyman cuts them to fit the frame,
allowing over-laps for sewing. When the birch bark plates are
cut and fitted by the master hand, the old women and their
young assistants gather alongside the craft and squatting on
the ground sew the sheets together and to the ribs with spruce
root threads, using a bone awl to open the way for the
insertion.... Olyman then runs some spruce pitch into the
cracks and small holes, paints the framework red, and
launches the craft upon the waters of the Kantishna for his
trip to the summer fish camps along the lower river. It is a
beautiful and graceful boat, and Olyman rides it fearlessly but
it is an accomplishment to be safely indulged in by the white
man only after long practice and many wettings.
James Wickersham, Old Yukon, 1938

Above: Making a birch bark
canoe.

Opposite: A woman works on a
traditional birch bark canoe, sealing
the seams with spruce pitch.
Canoes, used to navigate the rivers
and streams, were an important
part of the transportation network
in the Interior.

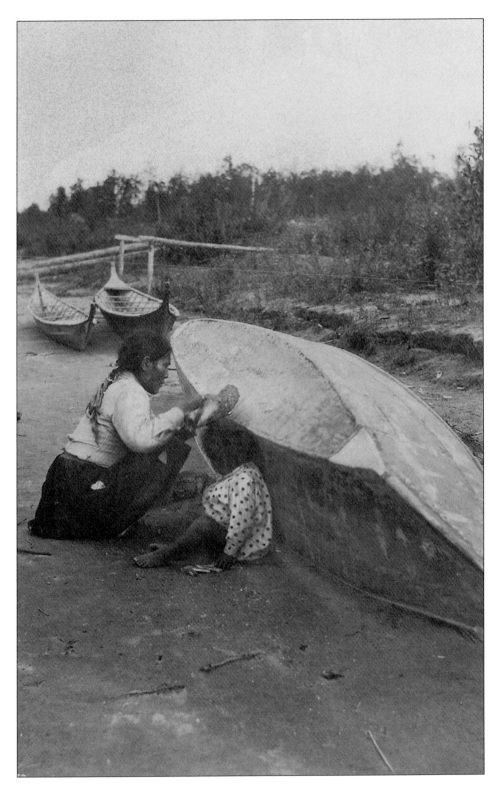

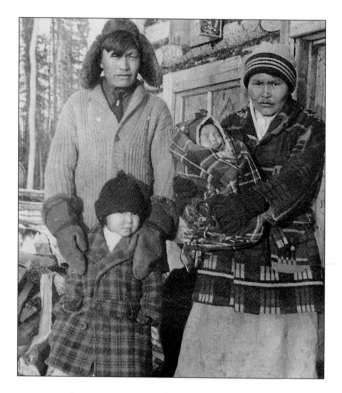

Lieutenant Joseph S. Herron led a military party in exploration across Rainy Pass from Cook Inlet to the headwaters of the Kuskokwim River.... His command comprised some twenty soldiers with a pack-train of horses, carrying heavy packs of supplies for their use. Reaching the great flat on the Kuskokwim side where the glacier streams coming down from the high snow-capped mountains spread their milky summer floods, the party became lost in the bush-covered swamps. Their animals mired and could go no further. In their bewilderment they piled the packs of supplies, turned their horses loose and the soldiers started northerly on foot.... It began to snow; the supplies carried on their backs gave out; they lost their way and were about to perish. Sesui, the chief of the Telida village was out hunting one day and ran across and followed a bear's trail until he found the animal and killed it. He ascertained the bear had been eating bacon, and being interested in learning where it had obtained this white man's food he followed on its back track, which finally led him to one of Lieutenant Herron's caches. Until that moment the Indian had not known there were white men, or bacon, in his country. He immediately set out to follow the white man's trail, and so found Lieutenant Herron and his soldiers, lost and starving in the maze of the Kuskokwim marshes. He took them safely to his village where he sheltered and fed them for two months and then guided them over his Cosna trail to the Tanana River.
James Wickersham, Old Yukon, 1938

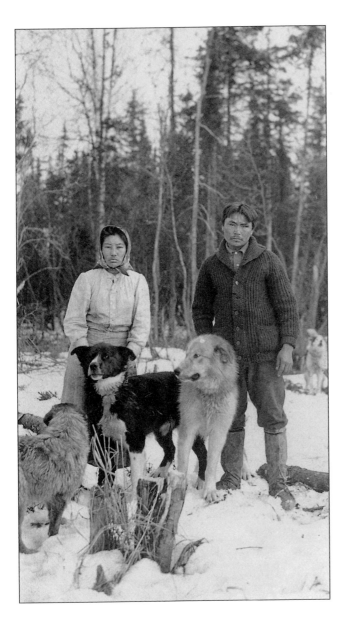

Opposite: Dick Thomas, Abbie and their children. Residents of the Minchumina-Kantishna area were often intermarried between the Upper Kuskokwim and Koyukon bands.

Above: Carl Sesui, his wife, and dogs.

Pages 14 and 15: The old village of Tolovana at the mouth of the Tolovana River.

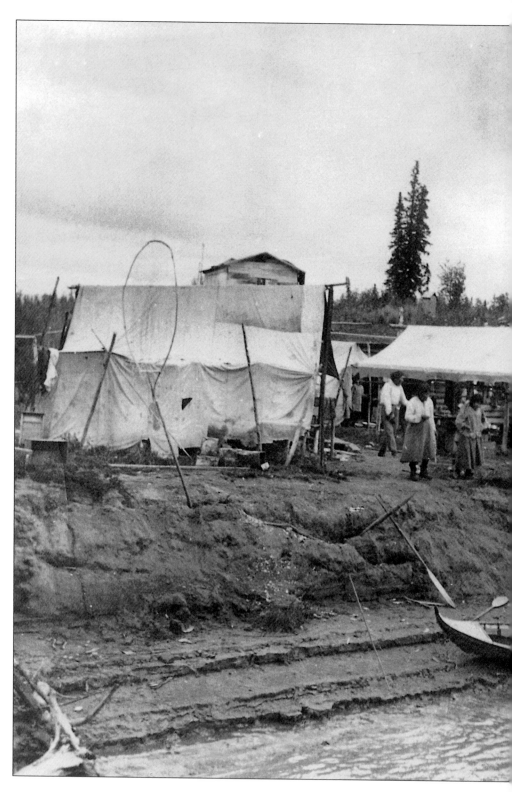

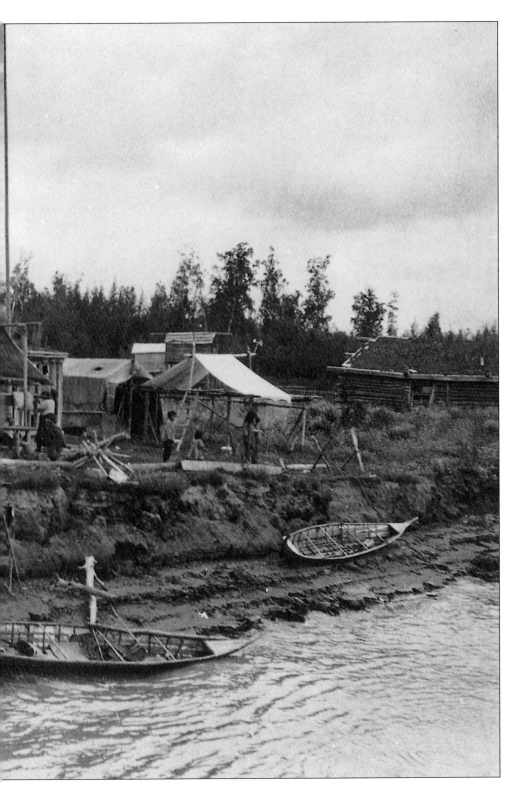

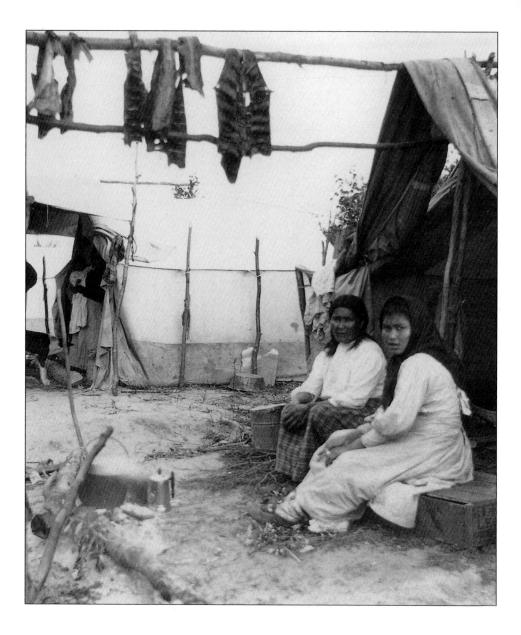

There were a lot of fish around there, Khutenal'ee [Moose Creek], at that time. So they would go there and make dry fish [in the summer]. Then they would also put away frozen fish after freeze-up. Just during the freezing-up month [October] the last of the salmon would come with their faces all worn away from traveling over the rocks and so on. They also used to fish for those with hooks of spears.... So that was a really good area, [it] provided us a good living.
Abbie Joseph, as told to Dianne Gudgel-Holmes, Kantishna Oral History Project, 1991

Above: Two women drying fish.

Opposite: Chiefs Charlie and William of Tanana. In those days there was a chief for every village.

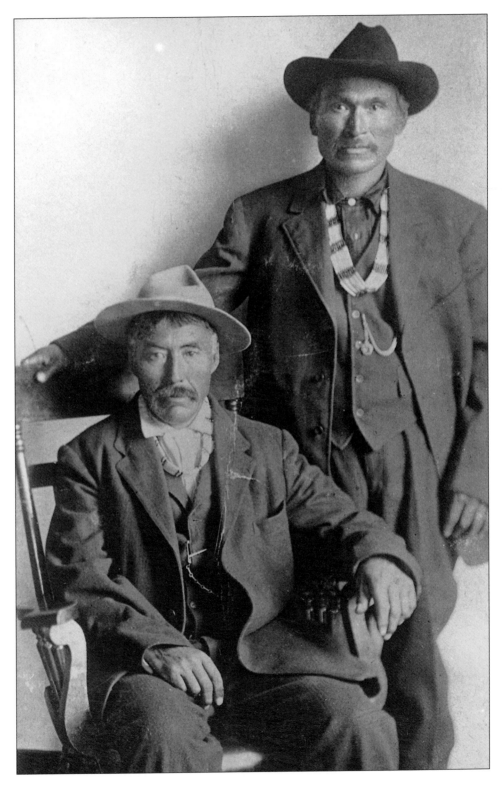

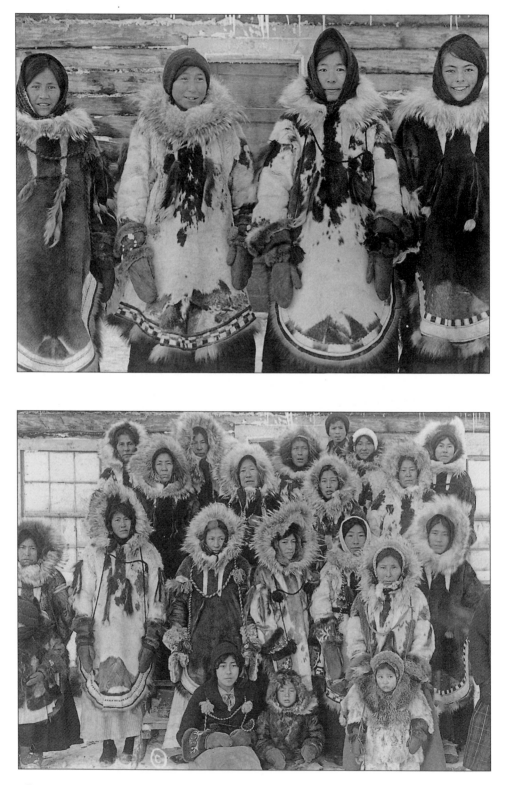

Opposite Top: Women in winter parkas.

Opposite Bottom: winter garb, Tanana.

Above: St. John and child, Roosevelt John and Slim William with bear spears at Lake Minchumina, 1916. The tall bear spears, with a sharp double-edged knife at the end were both practical and ceremonial. The bear would be lured out of his den in the fall, and the courageous hunter would prop the spear and wait for the bear to rise up on his hind legs and fall on it. Thus the spear was a symbol of a brave hunter.

The last time Roosevelt John traveled the McKinley River trail was in August or September of 1942, a few years before his death. He was an old man who had outlived three wives. His only children, two sons, had just died of the measles in Nenana. He rode the train to McKinley station where rangers sealed his gun. Then he walked alone through the Park to the McKinley River and down the trail to his Birch Creek home. (Elsie Mahaynay and Percy Duyck, interviews with Dianne Gudgell-Holmes)

People would say that this boy or girl was always just lucky. By adulthood these special people were known to have special powers. They could always have luck when hunting and they could tell everyone exactly where and when to hunt. Thomas took care of a lot of people he adopted children. He was a good provider. The Chief was kind. Chief Thomas was a really good man. He thought about his people more than himself. That's why he's Chief. This leader looked after everyone: That's the way Chief supposed to be. Looks at every house. If it looks like someone starving then Chief goes to every house and collects a little grocery. He takes it to them. And smart. The Chief was smart. He tell the people what to do, how to live right.
Nenana Denayee, Toghotthele Corporation

Above: Roosevelt John and his family at Lake Minchumina, April, 1919. Roosevelt John, second from left; Carl Sesui standing third from right, John Evan seated between two children. Abbie Joseph, who in later life provided many place names for anthropologists is seated third from right, and her mother second from right.

Opposite: Chief Thomas of Wood River was the big chief of the Nenana Indians as well. People said he was the last of the true old time chiefs (Kokhee or Doyon), of Nenana, Alaska. The people said that Chief Thomas truly embodied the qualities of the old time traditional chiefs.

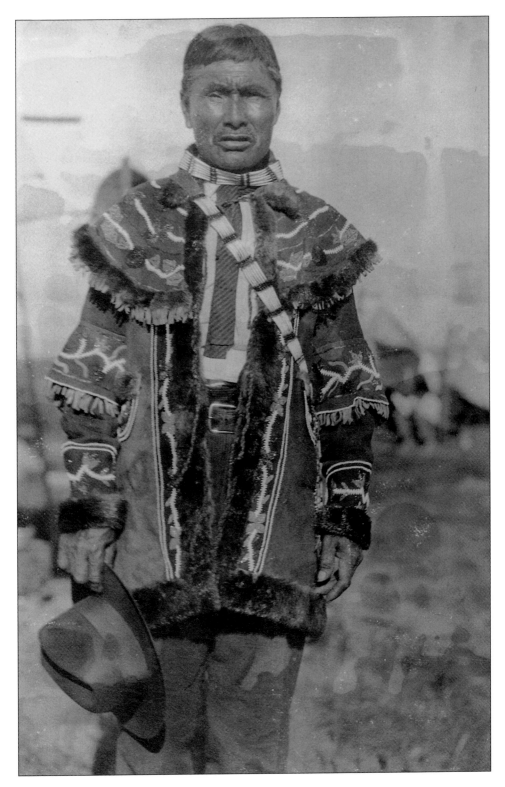

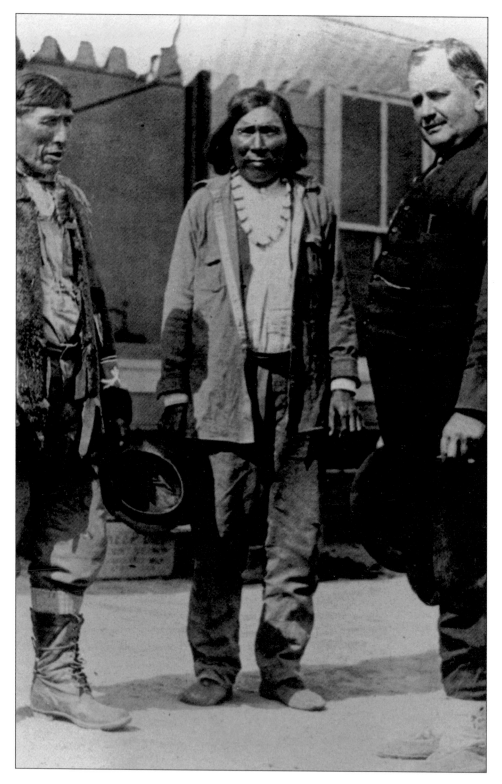

THE EXPLORERS

At the beginning of the 20th century, Mt. McKinley was as remote as the South Pole or Timbuktu, and as alluring—attracting dreamers, explorers, mountain climbers, and adventurers from all over the globe.

That an unimaginably tall mountain existed in the Interior of Alaska was almost a myth to the Russians who called it "Bulshaia Gora." While it was visible as a ghost-like mirage in the clouds on the horizon from the vicinity of present-day Anchorage, few Russians had ever actually been in that vicinity and seen it personally. Trader Arthur Harper was probably the first American to see the mountain as he made a famous pioneering trip down the Tanana River from the headwaters of the Fortymile in 1881. But prospector Frank Densmore, who made the crossing from the Kuskokwim to the Tanana, talked so much about it that everyone in the boomtown of Circle City called it "Densmore's Mountain."

The mountain came to the attention of a wider audience through the efforts of William A. Dickey, who brought unique qualifications to Alaska's outback. An easterner and graduate of Princeton, Dickey had lived in Seattle for a decade. Then he came north. Prospecting in the Susitna Valley with his partner, Monks, in 1896, Dickey became obsessed with the continuously visible yet unimaginably large massif.

Dickey's experience in the West had given him a familiarity with high mountains. The two men had often admired Mt. Rainier, towering over 14,000 feet; Monks was one of the few who had actually climbed it. Dickey and Monks used this experience on Rainier to estimate that the lower range between the Susitna River and the huge peak lay at about the same altitude as Rainier, while the peak itself seemed to loom at least 6,000 feet higher than its neighbors.

Judge James Wickersham consulting chiefs at Rampart following his attempted ascent of Mt. McKinley in 1903.

Using his connections, Dickey was able to publish what seemed a fantastic tale in the *New York Sun*, of January 24, 1897. Belmore Browne, who later attempted to

climb the peak three times, was the first to ask Dickey why he chose the name "McKinley." Dickey's answer was that after listening for many weary days to the arguments of two prospectors who were rabid champions of a free silver standard, he retaliated by naming the mountain after the champion of the gold standard, William McKinley, Senator from Ohio and Republican candidate for Vice President, later to become President.

In 1898, Robert Muldrow and George Eldridge of the United States Geological Survey were assigned to make an official determination of the height of Mt. McKinley. With a party of eight, they ran a surveyor's stadia line up the Susitna Valley and made altitude determinations from six different reference points using triangulation. Muldrow's final figure of 20,464 feet is remarkably close to the accepted height of 20,320 determined by modern methods.

In truth, few people had actually believed Dickey's tale of the looming 20,000-foot peak. When the official survey was published in 1900, it changed everything. And when an article appeared in *National Geographic*, Mt. McKinley took its rightful place as the highest point on the continent.

Young geologist Alfred Brooks was assigned by the USGS to explore and map the region in 1902. Backed by a party of seven men and twenty horses, Brooks took a route northwest from Cook Inlet through the Alaska Range to Rainy Pass. At the Pass they headed northeast, traversing the north side of the Alaska Range, passing close to the base of Mt. McKinley.

Crossing Rainy Pass, a traditional Athabascan route, Brooks encountered signs of a different breed of adventurer—the trapper who had wandered away from placer creeks, exploring, trapping, subsisting through each long winter in some remote spot, and then floating out in spring to the Yukon to trade for the next year's meager grubstake.

On August 4, the Brooks party made camp only 14 miles from the summit of Mt. McKinley. Brooks climbed a spur of the mountain to 7,500 feet and then described probable climbing routes in his own article

Opposite: Geologist Alfred Brooks, of the United States Geological Survey took a party of seven men with twenty horses on an expedition to explore and map the Mt. McKinley region in the summer of 1902. They left tidewater on Cook Inlet in early June and reached the base of the mountain near Peters Glacier on August 4.

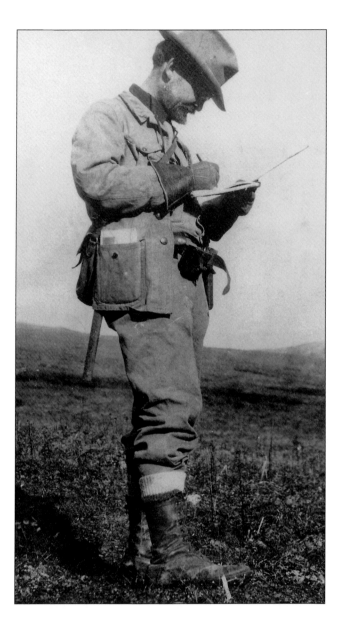

Though the mountain had been known to white men for over a century, and though scores of others had been as near it as this prospector, or nearer, he was termed the discoverer of Mt. McKinley. All honor to him for calling attention to it, but let us not make the absurd blunder of crediting him with its discovery.
Alfred Brooks, Journal of Geography, 1903

for *National Geographic*. That article inspired the next two expeditions.

In the summer of 1903, James Wickersham, Alaska District Court Judge for the vast Interior of Alaska, was the first to attempt to climb McKinley. Following him came Dr. Frederick Cook, who had already been to Antarctica with Roald Amundson. While neither climbed higher than 10,000 feet, their pioneering explorations set the stage and whetted the appetites of the expeditions to come.

Hunter and naturalist Charles Sheldon arrived in the area in 1906 to hunt for Dall sheep. Guided by young musher and mail carrier Harry Karstens, he arrived via the Kantishna River and explored the impressive high valleys between the peak and the Outside Ranges to the north. Sheldon's exploration came on the heels of a gold rush to the Kantishna Hills in 1905. Three boomtowns sprang up, only to be nearly abandoned by the fall of 1906.

Even as the eastern explorers and climbers, such as artist-adventurer Belmore Browne, reveled in their wilderness experiences far from civilization, they enjoyed the respite of a warm, dry miner's cabin and a delicious dinner. Most of them stopped at miner Fannie McKenzie Quigley's cabin for a five-course feast. Her dinners became part of the lore of the region.

Opposite Top: Wickersham's party took two mules named Mark and Hannah in honor of Senator Mark Hannah of Ohio, a friend of President McKinley.

A competitive and xenophobic tension grew between the Eastern and "outside" parties who visited Alaska to explore, and the resident "sourdoughs" who lived in the wilderness and off the land. This tension was to shape the plans that led to the first successful ascent of the North Peak, by Alaskans, in 1910, and of the South Peak, the true summit, also by Alaskans, in 1913. And it was to shape the concept of wilderness that led to the creation of a National Park, and to continuing disagreements about its development, preservation and use.

Opposite Bottom: Wickersham's party left Fairbanks on May 16th aboard the small steamer Tanana Chief heading for the mouth of the Kantishna River. They persuaded the captain to take them a distance up the river which had been up till then totally unexplored by non-natives.

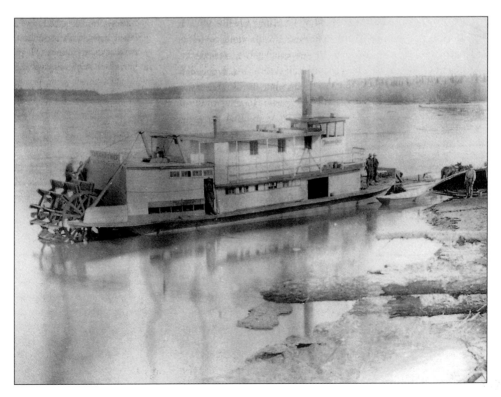

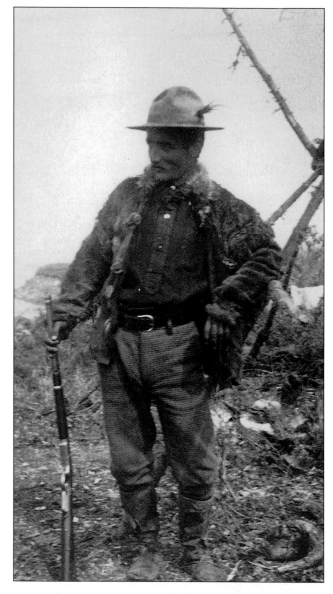

Above: John McLeod was chosen for his skills as an interpreter. The son of a Hudson's Bay company trader, he had spent most of his life near Fort McPherson on the McKenzie River. He spoke all of the Northern Dena languages.

Opposite Top: James Wickersham attempted to climb the mountain via the Peters Glacier, and discovered that it leads only to the base of the 10,000-foot cliff known now as the "Wickersham Wall."

Opposite Bottom: The swift-flowing McKinley River. Wickersham wrote, "we were relieved to find that a large spruce forest skirts the east side of the main McKinley Fork. This forest ought to be withdrawn from disposal and preserved for the use of those who shall come after us to explore the highest and most royal of American mountains."

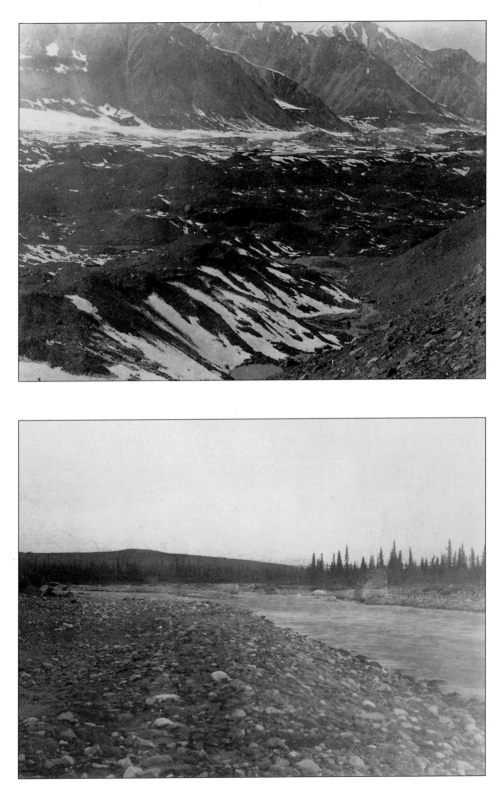

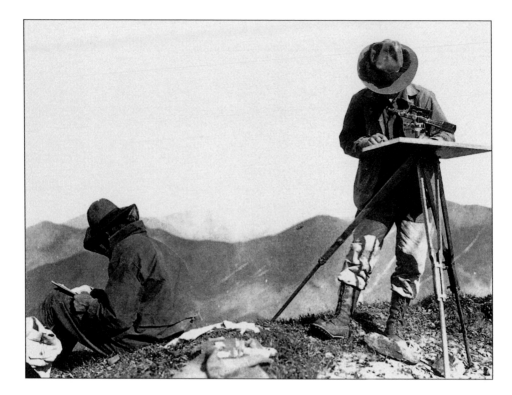

Often these pioneers make journeys that would put to shame the widely advertised explorations of many a well-equipped government expedition. Were the results of their efforts commensurate with the toil, danger and suffering involved, geographical sciences would be much enriched thereby. Unfortunately, their ideas of where they have been are often almost as vague as of where they are going.
Alfred Brooks, Journal of Geography, 1903

Above: The topographers and geologists of the United States Geological Survey made extensive expeditions on foot, packing their supplies with horses, and climbed numerous peaks in order to map the area.

Opposite Top: Charles Sheldon arrived in Kantishna in 1906 to explore the region and hunt for Dall sheep. Guided by Harry Karstens, Sheldon's was the first exploration of the park region by a naturalist.
Teddy Roosevelt, a personal friend, described Sheldon as "a capital representative of the best hunter-naturalist type of today."

Opposite Bottom: Stephen Foster and three dogs visiting Charles Sheldon's simple cabin on the Toklat in 1920.

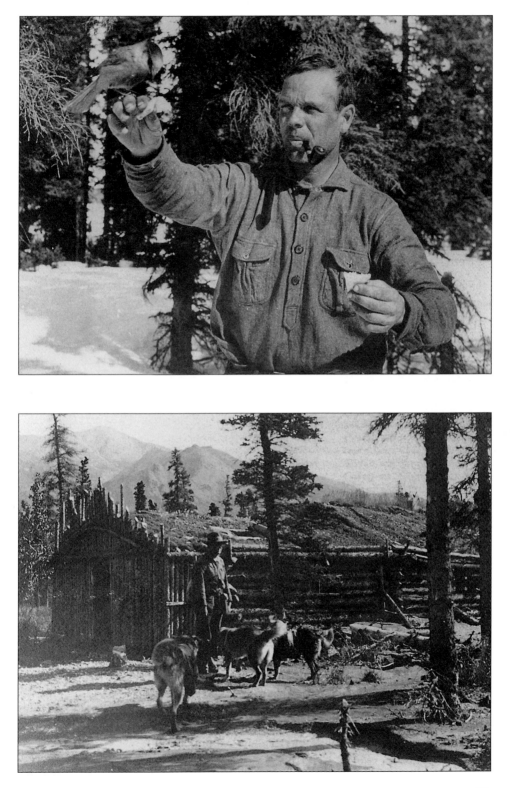

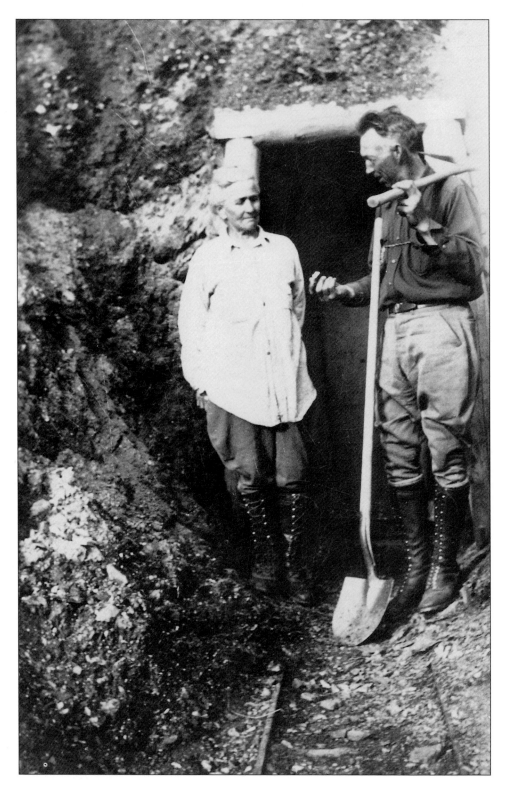

KANTISHNA GOLD

Prospectors from Rampart and Fairbanks headed for the Kantishna Hills in 1904. From Fairbanks, the 165-mile winter sled route led up the Toklat and over the foothills via the mouth of the Nenana River. From Rampart, on the Yukon River, prospectors headed south up the gold-bearing Minook and Little Minook Creeks to the divide, over the hills to Hot Springs on the Tanana, and then followed the Kantishna River upstream to the Bearpaw River, a total distance of over 150 miles.

Many of these prospectors had been disappointed in Dawson and flummoxed in Fairbanks. Now they moved on once again, attracted by news of the first claims in the hills filed by Wickersham and his companions. Joe Dalton, a veteran of the Klondike, found small amounts of gold near the Toklat River in 1904. The following summer, Dalton returned to the region with Jim Stiles. They staked Friday Creek on July 12 and Discovery Claim on Eureka Creek on July 20, 1905.

But, unknown to Dalton, long-time mining men Joe Quigley and Jack Horn were also prospecting the territory. They discovered gold in Glacier Creek and carried the news to Fairbanks in June, setting off a stampede. Dalton and Stiles were shocked when the first muddy, mosquito-bitten stampeders arrived and threw down their heavy packs on July 15, and promptly staked the rest of Eureka Creek.

By August, 1905, Fairbanks papers fed the credulous a steady stream of news about the strike. Dalton was taking out $500 to $1,000 a day ($8,000 to $18,000 in 1999 money) with a rocker, when $5 a day was considered good return. All the ground on Glacier, Caribou, Eureka and Eldorado Creeks had been staked. Gold fever burned so hot in Fairbanks that two of the six members of the Fairbanks City Council left for the Kantishna, and a third was planning to leave. Prospectors who could afford the fare traveled by steamer up the Kantishna and Bearpaw Rivers.

Miner and wilderness woman Fannie McKenzie Quigley stands in front of a mining tunnel with an unknown geologist. Fannie's husband, Joe Quigley, dug many prospect tunnels by hand in an effort to develop his hard rock claims on Quigley Ridge.

Golden aspen and birch leaves were mostly gone by September 25, as the steamer White Seal announced one last trip in before freeze-up. The transportation company estimated that 1,000 tons of supplies had been hauled to the new site, and that there were nearly 1,000 stampeders mining the streambeds in the Kantishna Hills.

Only 50 to 100 hard-bitten folk stayed to work through the winter of 1905-06. Temperatures could go as low as minus 60 in the remote camps above the timberline, where firewood had to be hauled 15 miles. The summer of 1906 saw a renewal of activity. Joe Dalton and his brother Jim employed 15 men on their claims on Eureka Creek. In mid-August, the Daltons and partners Joe and Simon Stiles returned to Fairbanks in glory, carrying $86,000 in gold dust ($1.5 million today).

While the paystreaks on Eureka and Glacier Creeks proved rich, the diggings on most of the other creeks were not as extensive as had been supposed and were quickly panned out. By the fall of 1906, the stampede was over and the population had dwindled to about 50.

Still, the Kantishna Mining District has been worked nearly continuously for 95 years. In the early years, intrepid miners worked the richest deposits with a minimum of technology, hand-shoveling gravel into crude sluice boxes. Eventually prospectors stepped up their efforts and found pay dirt far up the creeks. Throughout the next decade, ditches, flumes and primitive hydraulic outfits did their work on Glacier and Eureka Creeks.

Opposite: View of Friday Creek in the Kantishna Hills.

Many of those who stayed in the area began prospecting for hard rock deposits found in twisting veins and pockets running deep into the hillsides. Tall and lanky Joe Quigley, with his diminutive partner Fannie McKenzie, quietly worked his placer claims on Glacier Creek while simultaneously excavating hundreds of miles of exploratory tunnels on Quigley Ridge. Thomas Lloyd had a fair-sized operation on Glen Creek, from which he started in 1910 with some of his partners for the summit of Mt. McKinley. Joe Dalton stayed in the region until his death in the 1920s. In the process, those who stayed learned to live off the land and love the country. They took enough gold from their claims to

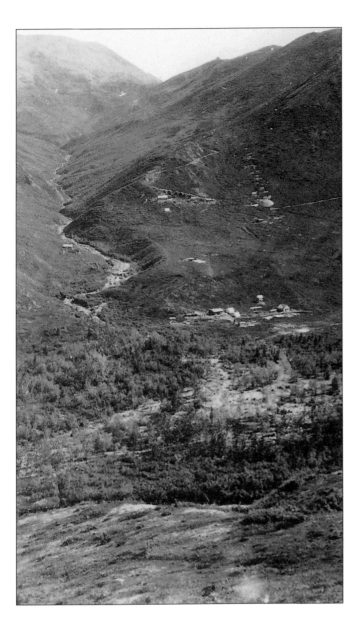

Everyone knows just what the country is who has ever been there, and the men who have struck the right kind of ground think, of course, that the country is all to the good, and a greater number, who failed to find the pay, think contrariwise. But personally, I don't believe that the Kantishna deserves the bad reputation it appears to bear.
Bob Mann, Fairbanks News, August 27, 1906

make a decent living, while continuing to look for the big strike they all hoped would finally repay their efforts. They always hoped the district would break out of its pattern of small, one- or two-person operations into bigger, more productive mines.

By 1919 a number of mineral veins had been located along a belt that extended 35 miles from Stampede Creek on the Clearwater Fork of the Toklat River, west through Wickersham Dome and Quigley Ridge to Slate Creek on the other side of Moose Creek, beyond Kantishna. Everyone hoped it would be another Juneau Gold Belt. The Quigley's Little Annie was leased and produced silver-lead ore from 1919-21. However, transportation remained a major impediment to development. As the Denali Park Road neared completion in the early 1930s, hope was renewed.

Quigley's final discovery, the Banjo Claim, high on the south side of Wickersham Dome, was leased by a group of Fairbanks businessmen in 1935 and developed as the Red Top Mine. At the same time, the Carrington Company of Fairbanks operated a hydraulic operation with a dragline, or dryland dredge, on Caribou Creek. Nevertheless, in 1942, all gold mining was shut down because of wartime restrictions.

Opposite: In the early days there was no equipment in the district and all mining was done with primitive hand methods. Miners built small dams on the creeks and used the water under pressure to wash away the dirt or overburden. Then they washed the gold-bearing gravel into crude sluice boxes.

An exception to wartime priorities was made for the Stampede Mine, a large antimony deposit discovered in 1916, because antimony, an alloy metal, was needed for wartime arms production. The mine was purchased in 1936 by Earl Pilgrim, the first mining engineering professor at the University of Alaska in Fairbanks, and an Alaskan mining legend. The Stampede's main asset was a spectacular vein of pure stibnite 26 feet wide. Under Pilgrim's management, the mine became the largest antimony producer in Alaska by 1941. The mine continued to ship ore until 1970, eventually shipping ore out by air after Pilgrim constructed an airstrip that could land C-146 cargo planes.

The hardy residents of Kantishna played a key role in the history of the mountain and the fledgling National Park. The explorers, climbers, geologists, biologists and park rangers who came into the country after 1905 were greeted by an entire community, relatively civilized, although remote.

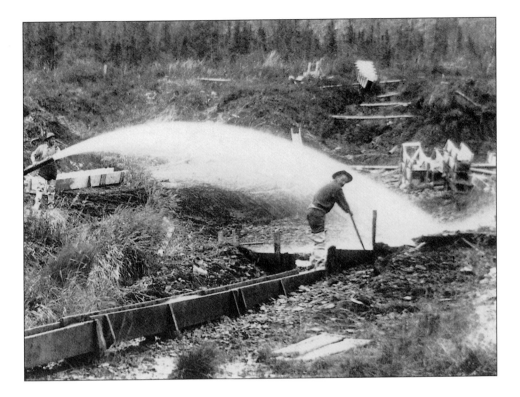

Jim Chronister and Billy Abramsky of the Kantishna were arrivals in town yesterday, having come in direct from the diggings. Chronister and Abramsky are operating on Glacier Creek, Sixteen Above, and outside of Dalton and Stiles have undoubtedly the richest diggings in the district. While they were non-committal as to the amount brought in as a result of the year's work, it is said the pokes they carried with them would choke an elephant.
Fairbanks News, September 10, 1906

There had been a stampede to Copper Mountain in 1921, but now [in the summer of 1926] only half a dozen prospectors were left at the diggings; still doing assessment work, and still hoping to find the hidden vein that the first rich find of float ore had come from. They were typical outdoor men, these miners—the kind you can spot anywhere, hard-working, conscientious, asking only to keep on with their digging in the hope of striking it rich.... They were the peculiarly persistent type who will hang on after all the first stampeders have pulled out. Their claims, and their tents, were spotted all over the alpine-moss hillside. Some had walled up rocks and dirt around the canvas for greater warmth; one man had gone to the enormous trouble of freighting up logs for a cabin, a feat his fellow prospectors undoubtedly thought was time unnecessarily taken from mining.

Grant Pearson, My Life of High Adventure, 1962

Above: The Quigleys and others prospected, staked claims and attempted to develop mining property high on Copper Mountain, now Mt. Eielson, in the heart of what is now the Park, opposite Eielson Visitor Center. July 17, 1922.

Opposite Top: Sacked ore at Bartlett's camp on the Kantishna River.

In 1919 Joe Quigley leased his Little Annie Mine on Quigley Ridge to Tom Aitken who took out 1,435 tons of Galena ore containing silver, lead and gold between 1919 and 1924.

Opposite Bottom: Corduroy Road, built for Tom Aitken to haul ore out of Joe Quigley's Little Annie Mine in Kantishna.

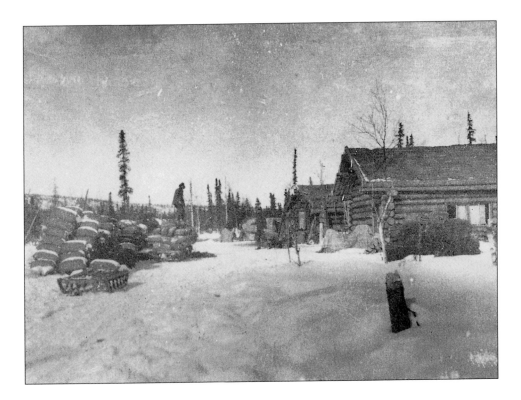

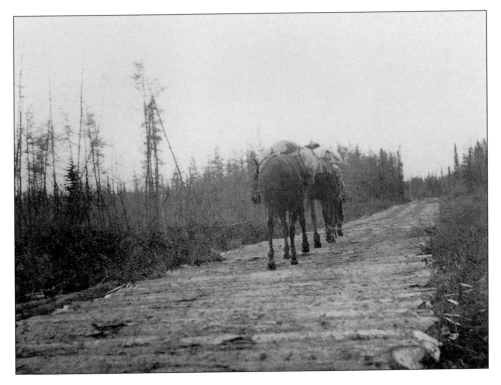

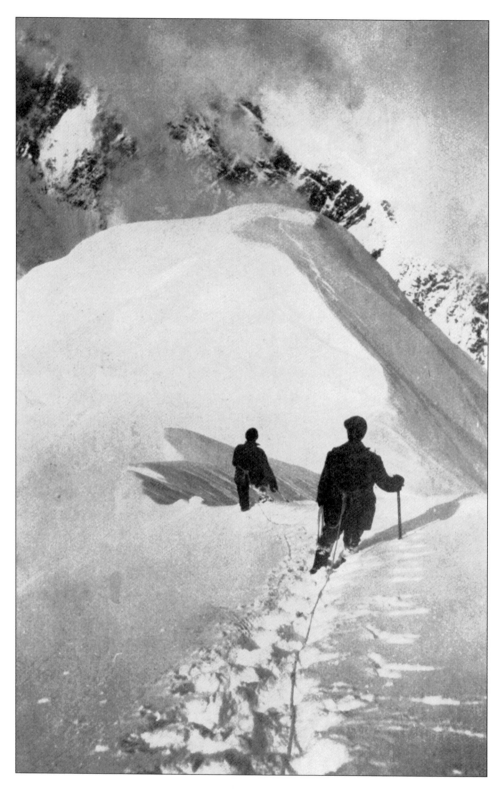

TO THE TOP OF
THE CONTINENT

To the explorers and adventurers of America's settled East Coast, Mt. McKinley was as remote as the North Pole and as alluring as Africa. Planning and financing an expedition, and just getting men and equipment to Alaska, was an adventure in itself. Preoccupations with climbing the great peak, and then writing about it, kept Mt. McKinley in the public eye for a romantic decade. Nearly a dozen books were published. Countless articles in magazines such as *Harper's*, *Outdoors*, *Scribners* and *National Geographic*, bearing titles such as "To the Top of the Continent," or "Conquest of Mt. McKinley," serialized these true-life adventures. But it took nine expeditions before anyone reached the true summit of the South Peak in 1913.

However, to the miners, prospectors, trappers and entrepreneurs who had settled in the Interior as a result of various gold rushes, Mt. McKinley was an enticing presence, always beckoning on the horizon. Alaskans attempting to reach the summit from the north had the advantages of geography and experience with wilderness travel. But it was the expeditions of the well-known Outside explorers which received the majority of the publicity and recognition. Not until missionary Hudson Stuck combined his fund-raising ability and credibility as an Episcopal archdeacon with the seasoned experience of his own dog-sledding and of hearty Alaskan outdoorsmen was the mountain finally conquered.

Following the Alfred Brooks expedition of 1902, and Brooks' article in *National Geographic*, came two expeditions in 1903. The first was a leisurely affair undertaken by Judge James Wickersham and a few hand-picked companions, who headed up the Kantishna River following the directions of Athabascan hunters.

In contrast was the well-publicized expedition of Dr. Frederick Cook, who had been with Amundsen's first

The Herschel Parker-Belmore Browne expedition tackles the Northeast Ridge on their 1912 expedition.

Antarctic Expedition in 1897. Cook's party left New York City with great fanfare about the same time Wickersham slipped out of Fairbanks. By the time Cook's men and packhorses reached the head of Cook Inlet in June, Wickersham's party had already completed their summit attempt via Peters Glacier and was heading back to Rampart. Cook did not reach Peters Glacier until August 24, after spending more than a month crossing the Alaska Range. The New York group even stumbled upon Wickersham's humble camp, where they salvaged a red metal can of salt, the one item they lacked—this after considerable bravado over being "the first white men" in the virgin wilderness.

Running short of food, the Cook expedition devoted only a few days to their attempted climb, and succeeded only in climbing a few thousand feet higher than Wickersham's party before abandoning the effort. Then, with cold weather stalking their heels, they hurried east through the high valleys and managed to take their horses through a pass in the Alaska Range and back to the headwaters of the Chulitna River. Here they abandoned the poor animals and rafted down the wild river.

In spite of the failure of his first McKinley summit attempt, this 1903 circumnavigation of the massif enhanced Cook's reputation as an explorer, and he was able to put together a capable party for a second attempt in 1906. After weeks on the Ruth Glacier, Cook ditched his experienced partners and then claimed to have run to the top of McKinley and back in two weeks with only his packer. This attempt resulted in some curious photographs and the infamous Fake Peak controversy. The Fake Peak affair clouded Cook's claim to have reached the North Pole in 1908, and debate still rages today.

The exploits of the enigmatic yet highly publicized Dr. Cook did much to put Mt. McKinley on the world map of explorer challenges. Cook's companions, Columbia physics professor Herschel Parker and artist and outdoorsman Belmore Browne, put their experience to use in 1912 and came within two hundred feet of the summit, only to be turned back by a raging storm. (Even today, half of those who attempt McKin-

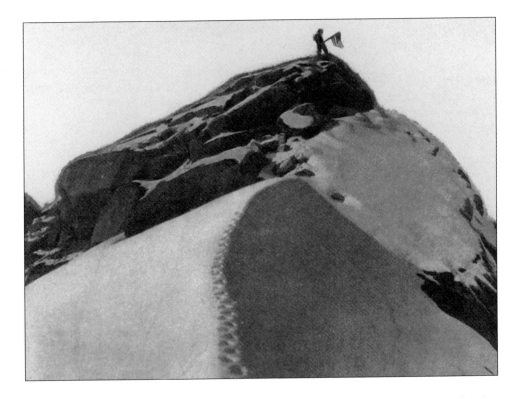

In 1907 Cook's illustrated article with a photo of the summit of Mt. McKinley and a map showing the purported route appeared in Harper's Magazine. Except for a small group of skeptics, Cook's claim to the summit of McKinley was popularly accepted and he was elected president of the prestigious Explorer's Club.

In 1908, Dr. Cook published "To the Top of the Continent" to favorable reviews. But poor cropping of the summit photo in the book left the ragged edge of a peak showing in the background. Parker and Browne matched the peak falsely labeled as the summit with another photo captioned "the View from 16,000 feet" and exposed the hoax.

Dr. Cook also claimed that he reached the North Pole on a polar expedition on April 21, 1908. With Cook's personal integrity as his only proof of his polar claims, he came before a committee of the Explorers Club in late 1909. Claiming that polar hardship had affected his memory, Cook asked for two weeks more time to gather his evidence. Then he disappeared.

On December 24, 1909, the committee rejected his claim to have reached the summit of Mt. McKinley, and Cook was officially expelled from the Explorer's Club.

ley do not reach the summit, often forced to retreat by 100-mile-an-hour gales.)

Meanwhile, Tom Lloyd led a team of four Kantishna prospectors who thought they could show the eastern explorers a thing or two, and put together an expedition in their backyards. The summit of McKinley was only 25 air miles from their mining claims, and they had all viewed its wonders daily since their arrival in the Kantishna District.

What the Kantishna miners lacked in alpine experience and equipment, they made up for in Sourdough inventiveness. They took no ropes, only homemade crampons and primitive snowshoes. Their successful ascent was aided by their knowledge of the terrain and geography, and by Charley McGonagall's discovery of a shortcut from the McKinley River to Muldrow Glacier, now known as McGonagall Pass.

With no ropes, the Sourdoughs cut 750 willow poles to mark their route on the glacier to their base camp at 11,000 feet. ("Wanding"—probing for crevasses, and marking safe routes with wands—is a technique still used today.) Then, since no one told them it couldn't be done, Billy Taylor and Pete Anderson stuffed their rucksacks with homemade doughnuts and hot chocolate and carried a 14-foot spruce pole to the top of the North Peak in one determined 18-hour push. Had they not mistakenly thought that the North Peak was highest, they would surely be credited with the first ascent of McKinley.

It was left to Hudson Stuck, Harry Karstens, Walter Harper and Robert Tatum to put together the lessons learned from previous expeditions into the successful first ascent in 1913.

For the route to the mountain from Fairbanks, the Stuck expedition followed the example of the Sourdoughs. For information on the climb up to the south peak, they had the articles written by Belmore Browne. But when they reached the 11,000-foot camp on the Muldrow Glacier, they received a great shock: the smooth route up the Northeast Ridge described by Browne, and completed in less than a day by the Sour-

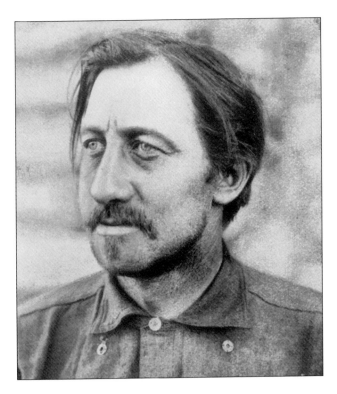

Above: Dr. Frederick Cook made his first expedition to the mountain in 1903, and returned in 1906. At the end of a fruitless search for a climbing route from the Ruth Glacier, he dismissed his experienced partners, Herschel Parker and Belmore Browne, and after rejoining them two weeks later, claimed he had successfully made the summit, a claim Parker, Browne, and others found incredible.

doughs, had disintegrated as a result of the powerful Katmai explosion and earthquake the previous year. What greeted Stuck and Karstens was a jumble of ice blocks the size of houses—an obstacle course which took them three weeks to negotiate.

The expedition had come prepared with enough supplies to besiege the mountain and outlast its fickle weather and notorious storms. On June 7, 1913, they left their camp at 17,500 feet and made their final assault. Backed by a north wind and with not a cloud in the sky, young Athabascan Walter Harper was the first man to set foot on the summit of Mt. McKinley.

Above: The "Sourdoughs" from left to right, Charles McGonagall, Tom Lloyd, Pete Anderson, and Billy Taylor, all miners from Kantishna who mounted the first expedition to successfully summit the North Peak of Mt. McKinley.

Opposite: This rare photo of Charlie McGonagall and Tom Lloyd of the famous All Alaskan Sourdough Expedition with their home-made clothing and equipment at their 15,000-foot camp on Mt. McKinley was published in the New York Times account of the climb.

Pages 48 and 49: Mt. McKinley rises over 10,000 feet from the northern valley of the McKinley River.

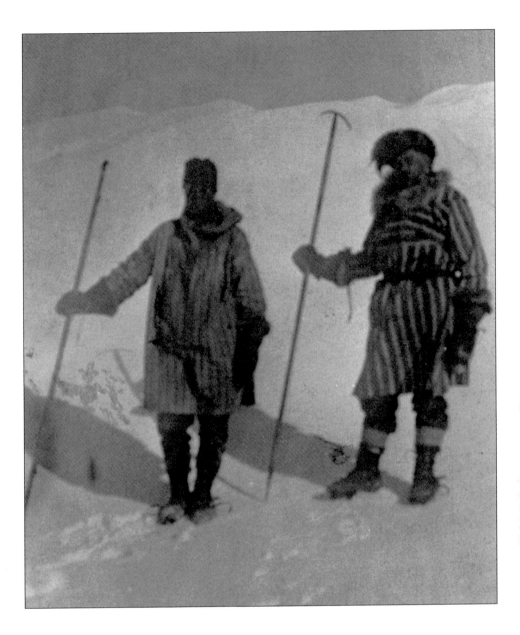

Anderson had a frozen toe from the start of the trip to the finish—towards the end, it bled something fierce every night, When we asked him about it, he would say, "Well, it is a bit sore", as a fellow would say.... In coming down the glacier on the final descent, Bill Taylor's foot slipped, he slid two hundred feet, and then caught on the hook of his pike pole, headed for a sheer precipice.
Tom Lloyd, New York Times, 1910

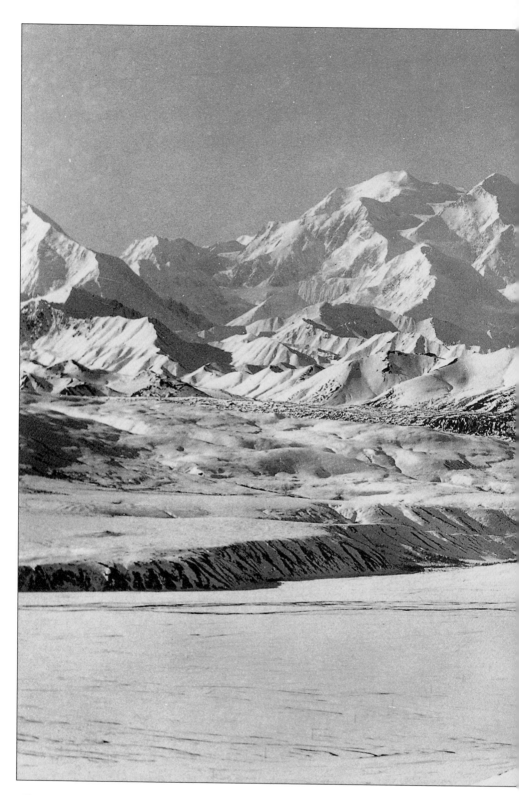

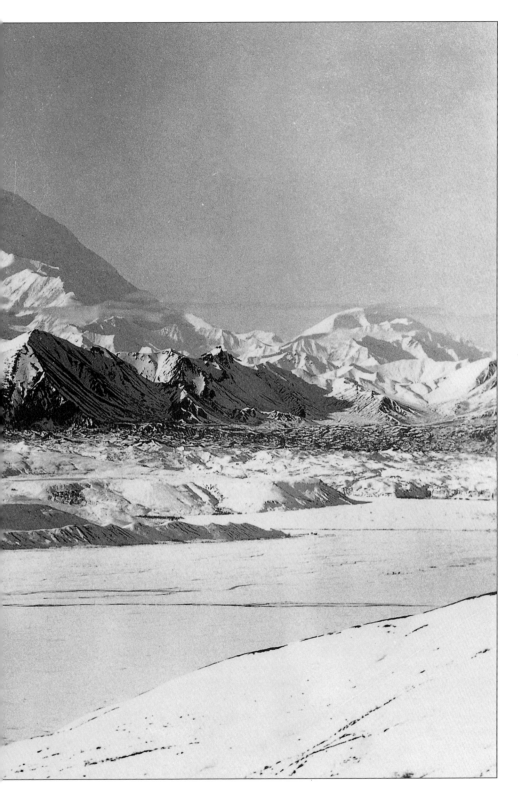

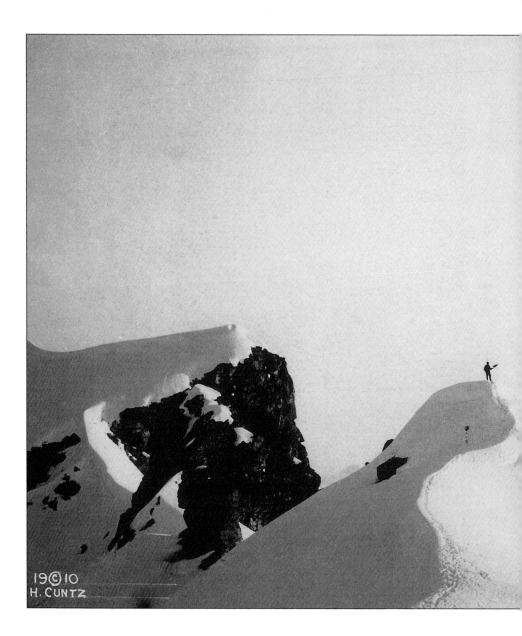

To old timers like McPhee, Cook's lies were especially insulting, as long-time Alaskans tended to believe anyway that most so-called explorers were city-bred eastern dandies who seldom ventured off the sidewalk without their knee-britches, dinky caps, "pneumatic pillows" and silk underwear and earned headlines for trips that the average pioneer would consider no great hardship.
Terrence Cole, The Sourdough Expedition, 1985

Above: In 1910, Parker and Browne mounted an expedition to prove that Cook had faked his ascent. They found and photographed the "Fake Peak" with its real background.

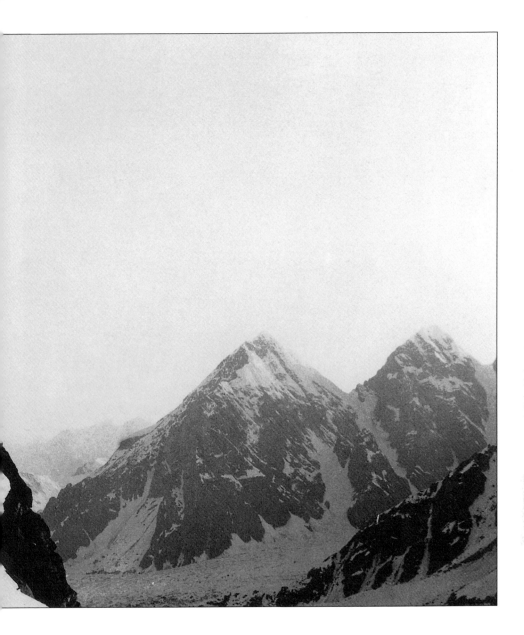

*They reached the saddle, no longer expecting to find a high peak, and stopped for lunch.
A few minutes later we began the ascent of the snow saddle on the way to the top of the cliff.
Professor Parker had started a few minutes before, and, as we turned to follow the saddle we
heard Professor Parker shout, 'We've got it!' An instant later we saw that it was true—the
little outcrop of rock below the saddle was the rock peak of Dr. Cook's book, under which he
wrote, 'The Top of our Continent—The summit of Mount McKinley; the highest mountain of
North America—altitude 20,390 feet.'*
Belmore Browne, The Conquest of Mt. McKinley, 1913

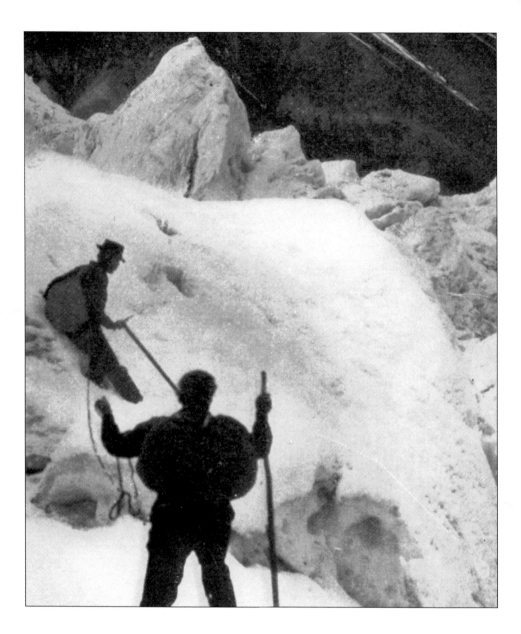

We took a straight course up the great snow ridge. Above us nothing was visible but snow; the rocks were all beneath, the last rocks standing at about 19,000 feet. Our progress was exceedingly slow. It was bitterly cold. We were all clad in full winter hand and foot gear—more gear than had sufficed at 50 below on the Yukon Trail, until high noon feet were like lumps of iron and fingers were constantly numb.
Belmore Browne, The Conquest of Mt. McKinley, 1913

Above: Belmore Browne and Professor Herschel Parker were veterans of both the 1906 Cook Expedition and the 1910 expedition to the Ruth Glacier. In 1912 they led one final attempt to reach the summit of Mt. McKinley.

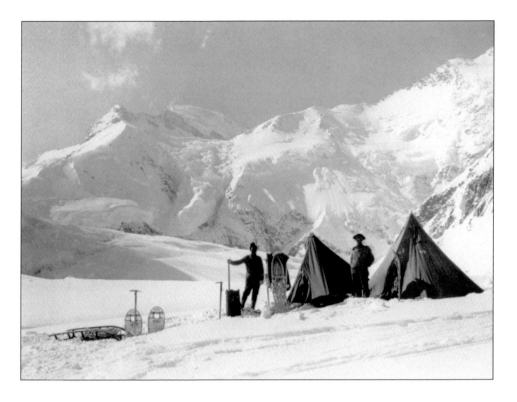

Above: Climbers at a camp high on the Muldrow Glacier. This team was organized to recover the bodies and scientific journals of Allen Carpe and Theodore Koven. August, 1932.

Allen Carpe and Theodore Koven had planned to camp at 11,000 feet to measure cosmic radiation. They had their equipment flown to the Muldrow Glacier by Joe Crosson who made the first glacier landing. Carpe and Koven reached the head of the glacier and set up camp, but then headed back down to greet their team mates. The tragedy was discovered by the Lindley-Lieke climbing team on their descent after successfully reaching the summit. Following ski tracks from the deserted camp at 11,000 feet, they discovered the frozen body of Theodore Koven, and further on, the whole story unfolded.

At the edge of the crevasse lay an ice axe and a pair of crampons. Faint ski tracks told us that the man who was ahead had passed over the crevasse safely on the snow crust, that the man behind had fallen through, and that the man ahead had come back to help him out. The tracks showed that the skier ahead had sidestepped carefully up to the edge and there the snow had caved in and hurled him into the crevasse. We couldn't tell of course whether it was Allan Carpe or Theodore Koven who had broken through first. But we knew now that it was Koven who had got himself out and had started back to his camp perhaps to get a rope to throw to his friend. Being badly hurt, he had fallen exhausted and frozen. Grant Pearson, My Life of High Adventure, 1962

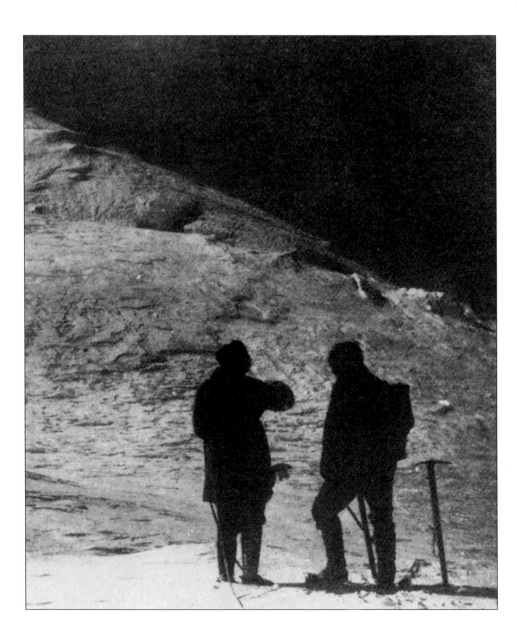

Above: Parker and Browne passed the last rocks and got the first clear view of the summit. "It rose as innocently as a tilted snow-covered tennis court." But the summit was not to be theirs. The wind increased, the southern sky darkened, until they were facing a snow-laden gale. As they topped the final rise, the full fury of the wind hit them. Finally they agreed it would be suicide to continue.

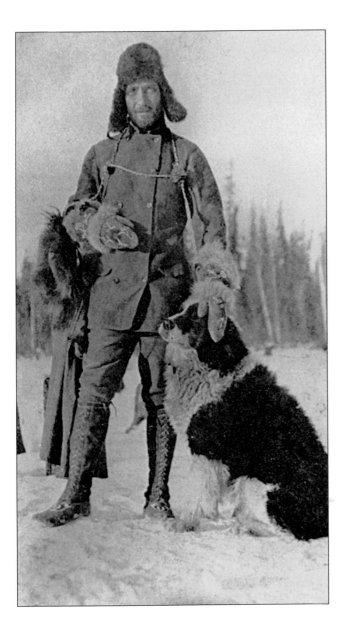

Above: Episcopal Archdeacon Hudson Stuck was 50. For 10 years he had traveled his vast parish by dog-sled in winter and river boat in summer. Like Wickersham, he had fallen under the spell of the great mountain visible nearly everywhere throughout his vast territory.

At last the crest of the ridge was reached...we were well above the great North Peak across the great Basin...there still stretched ahead of us, and perhaps a hundred feet above us, another small ridge with a north and south pair of little haycock summits. This is the real top of Denali....With keen excitement we pushed on. Walter, who had been in the lead all day, was the first to scramble up; a native Alaskan, he is the first human being to set foot upon the top of Alaska's great mountain, and he had well earned the lifelong distinction.
Hudson Stuck, Ascent of Denali, 1913

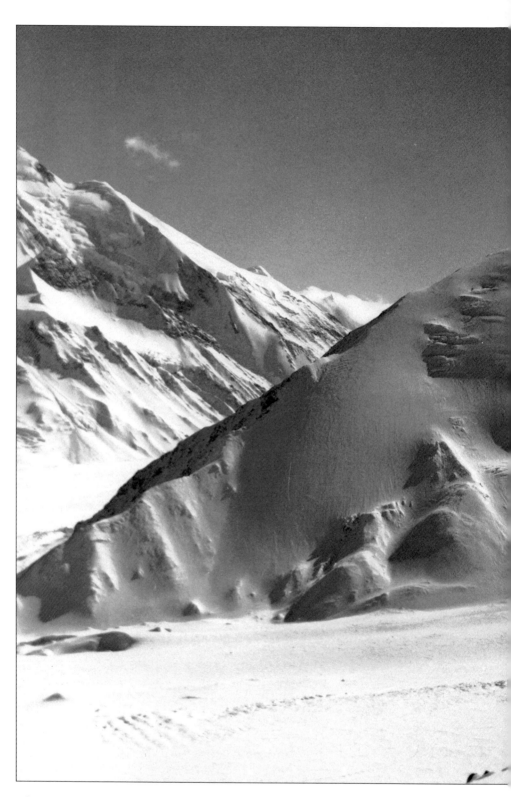

March 13: Took stove, tent and bedding to Wall Street Glacier.... It is the grandest thing I ever saw in my life—that long stretch of glacier.

Going across the glacier to McKinley for the first four or five miles, there are no crevasses in sight...but the next eight miles are terrible for crevasses. You can look down in them for distances stretching from 100 feet to Hades or China. Look down in one of them, and you will never forget it. Some of them you can see the bottom of, but most of them appear to be bottomless. These are not good things to look at.
Tom Lloyd, New York Times, 1910

Opposite: The Sourdoughs' first major breakthrough came as Charlie McGonagall explored the upper reaches of Cache Creek for a route over the front ranges to the Muldrow Glacier. His discovery of McGonagall Pass, leading onto the Muldrow Glacier at about 6000 feet, cut nearly 25 miles of treacherous glacier travel, and was used by all subsequent parties until after World War II. The Sourdoughs called it the Wall Street Glacier, because of its high enclosing walls.

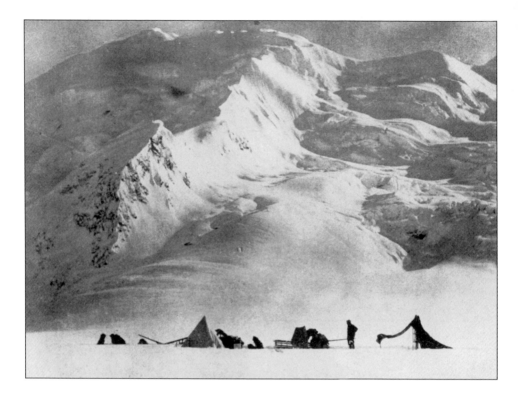

On the northern side of the range was not one cloud.... On the humid South side, a sea of clouds was rolling against the main range like surf on a rocky shore....The clouds rose as we watched. Soon every pass was filled with cloud battalions that joined forces on the northern side, and swept downward like a triumphant army over the Northern foothills. It was a striking and impressive illustration of the war the elements are constantly waging along the Alaskan Range....

On the southern side hang the humid cloud-banks of the Pacific Coast, the very farthest outpost of the cloud armies of the Japan Current; on the north stands the dry, clear climate of the interior, while in between, rising like giant earthworks between two hostile armies, stands the Alaskan Range.
Belmore Browne, Conquest of Mount McKinley, 1913

Above: "There was an overpowering sense of solitude." Parker Browne expedition, camped on the mountain.

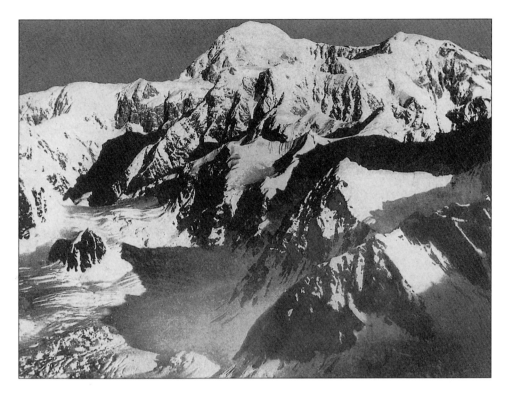

Above: Mt. McKinley from the southeast in a photograph taken by Parker-Browne expedition photographer Merl LaVoy.

I shall always remember vividly this day's travel of eight miles or more up the bars of the McKinley Fork to the limit of spruces at the lower end of the dead moraine of Peters Glacier. It was calm, with patches of clouds above in the deep blue sky. Directly ahead was Denali, surrounded by an amphitheater of lower peaks, and with lofty ranges sweeping away on both sides. Such a view is so overpowering and sublime that words cannot describe it. And now with the heavens a glory of color, the greatest of word artists could scarcely hope to convey more than a suggestion of the depth and intensity of its impressiveness. It was before us all day, and under varying lights for many days thereafter. I am glad that my journal is filled with records of it because neither memory nor imagination could bring back its magnitude, nor my emotions beholding it.

Groups of heavy clouds hovered along the crests of the entire range, all highly colored and gold fringed when touched by the sun. Some were of varying shades of gold, yellow, pink, and crimson, all deepening with the sinking of the sun, while at the same time the vast snowfields took on a reflected rosy hue; and clouds forming about Denali appeared like vast camp-fires succeeding one another in the spaces beyond.
Charles Sheldon, December 17, 1907

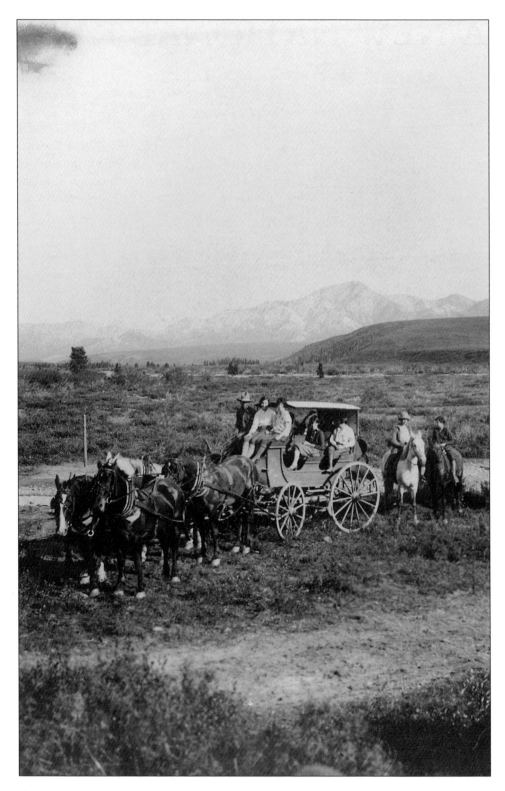

A NEW NATIONAL PARK

As eastern big game hunter Charles Sheldon endured the lonely yet ecstatic winter of 1907-08 on the Toklat River in the Denali Wilderness, the idea came to him of creating an Alaskan national park. Back in New York in 1908, he turned for support to the Game Committee of the Boone and Crockett Club, an organization of trophy hunters with prestigious members and Washington connections.

At the time, there were 13 national parks including Yosemite and Yellowstone, but no coordinated administration. Sheldon's idea for a national park showcasing Denali would have to wait while the debate about the creation of the National Park Service occupied Congress. When the debate was over, the statement of purpose for the new Service contained the intrinsic contradiction between preservation of wilderness and enjoyment by humans which remains the central dilemma of the National Park system today:

"That the purpose of the proposed National Park Service is to conserve the scenery and the natural and historic objects and the wild life therein and to provide for the enjoyment of the same in such a manner and by such means as will leave them unimpaired for the enjoyment of future generations."

The goal of the new National Park was to provide for the enjoyment of the public as well as preservation of the natural environment. The Mt. McKinley Tourist and Transportation Company acquired two stage coaches, used previously at Yellowstone Park, to provide transportation for early tourists.

Sheldon presented his plan for the creation of Denali National Park in October 1915. He suggested that the boundaries of the proposed park include the high valleys and "sufficient outside forested country for the moose range toward the west"—boundaries very close to those adopted in the final bill. As he outlined his idea for his old friends E. W. Nelson of the Biological Survey and conservation pioneer George Bird Grinnell, Sheldon knew that an important first step was to win the support of Judge James Wickersham who by then was an important statesman, sole delegate to Congress from Alaska. With Wickersham's support, Sheldon intended to persuade a few influential congressmen and senators and the Secretary of the Interior, and then officially kick off his plan at a formal Boone and Crockett dinner.

Wickersham gave Sheldon's plan his approval, after inserting language into Section 6 of the proposal, allowing for the continuation of mining activities and for prospectors to continue to harvest game in emergencies. (Wickersham knew how important the pioneer values of mining and hunting were to his constituents.) Although Sheldon had suggested that the new park be called Denali, that idea was dropped, presumably because it was considered politically inexpedient to slight the former Vice-President.

Wickersham, Belmore Browne, Charles Sheldon, George Bird Grinnell, and others spoke eloquently for the proposed park at House and Senate hearings in May 1916.

A new sense of urgency about preserving the park had been created by the impending construction of an Alaska railroad. Sheldon and others felt that with railroad tracks soon to run within 20 miles of the proposed park, its game would be endangered by market hunters. While preservation of the area as a game refuge was an impetus in the minds of those who envisioned the park, they unabashedly used economic development arguments to promote the idea. As a scenic destination for tourists traveling comfortably in Pullman cars, the park would, after all, be an economic asset to the federally-owned railroad, and to all Alaska.

Congress finally passed the bill creating Mt. McKinley National Park, and Charles Sheldon carried it by hand to the White House where President Woodrow Wilson signed it on February 26, 1917.

At the start, no money was appropriated for operations. By 1921, however, as the railroad neared completion, predictions about the increased pressures on the park had indeed come to pass. Charles Sheldon and other friends of the park labored to get a small budget approved, chiefly to ensure protection of wildlife. Though many of the wildlife advocates might have been satisfied with a park that emphasized protection only, the new National Park Service was reluctant to seek funds from Congress for a park accessible to few visitors. The pressure to make the park accessible and to provide suitable accommodations led to new priorities.

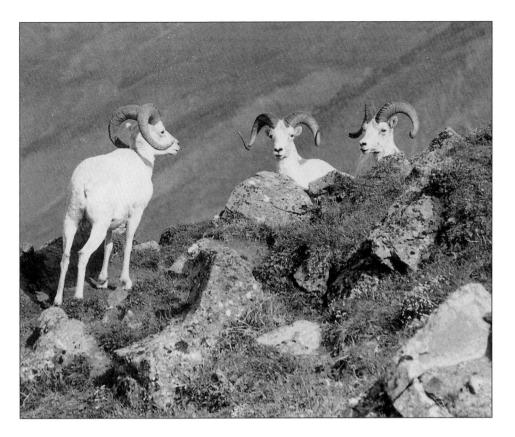

Above: Mature Dall sheep occupy a rocky slope.

That season's experience among the white sheep convinced me that I really knew very little about their habits. I realized that their life history could not be learned without a much longer stay among them, and determined to return and devote a year to their study.... I do not see how one could spend a better year in the wilderness than build a cabin at the head of the Toklat, have a tent, and during the winter travel about. One could enjoy the wilderness among the most wonderful mountain range of the continent, and undoubtedly the best game country.
Charles Sheldon, Wilderness of Denali, 1930

At Sheldon's suggestion, Harry Karstens was appointed as the first permanent Park Superintendent in 1921. Congress' total appropriation for operations was only $8,000, which would be stretched to cover salaries for the superintendent and a ranger, and funds for three horses, two teams of five dogs each, equipment and supplies. Headquarters was at Nenana, 60 miles from the park.

Karstens' experience and familiarity with the area and most of its residents allowed him to make a quick start on boundary protection. Mushing his own teams to the remote boundaries, using trappers' and prospectors' cabins for shelter, he posted boundary signs and discouraged poachers. By 1912, the raw boomtown of Fairbanks was nearly 10 years old. The richest ground in Alaska's interior had been mined, and the hue and cry for transportation to aid in economic development reached a crescendo. While various companies had attempted to construct railways from the coast, none had reached all the way to the Interior. Government incentives to railroads at the end of the 19th century had seemingly backfired in one bond failure after another. As a result, Congress was reluctant to subsidize another private railroad with the old system of land grants. It seemed as if the only alternative was to have the government construct it.

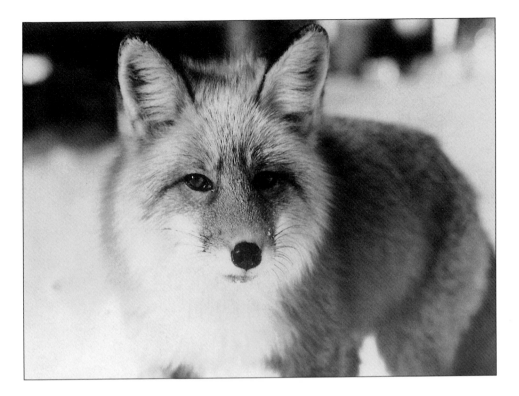

Above: Arctic red fox.

When Denali National Park shall be made easy of access, with accommodations and facilities for travel, including a comfortable lodge at the foot of the moraine of Peters Glacier—as surely it will be—it is not difficult to anticipate the enjoyment and inspiration visitors will receive. They will be overwhelmed by the sublime views of Nature's stupendous upheaval, as so many have been by the Grand Canyon of the Colorado, Nature's great excavation. And it may be added that no one can realize the greatest glory of Denali until he shall behold it in December or early January, the period when the sun is lowest, when the sky radiances reach their greatest intensification and deepest coloring. Thus to view Denali towering in a sky of unimagined splendor evokes a state of supreme exaltation.
Charles Sheldon, Wilderness of Denali, 1930

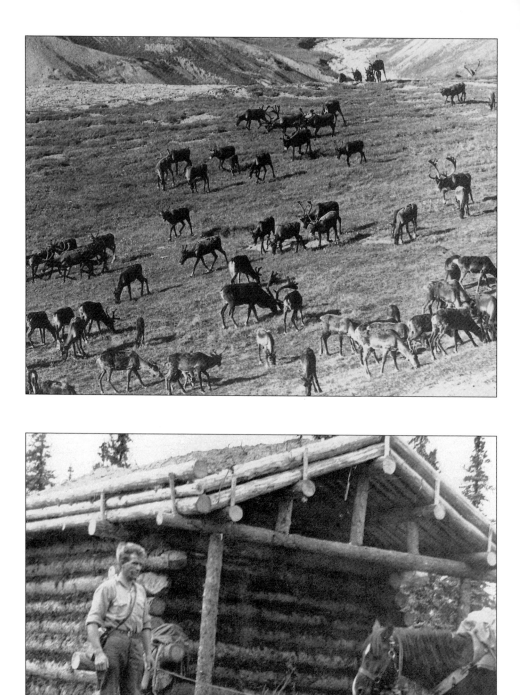

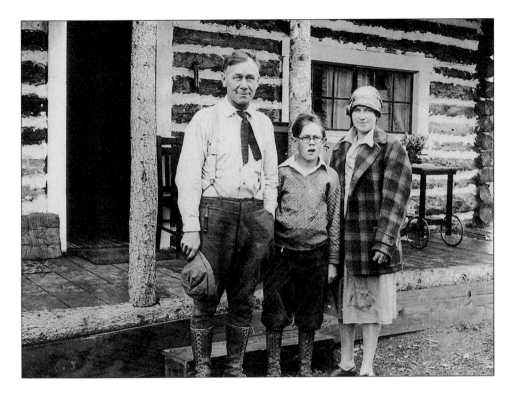

Opposite Top: Caribou herd.

Opposite Bottom: Future Park Superintendent Grant Pearson as a young ranger at the McLeod Creek patrol cabin in 1927.

Above: Harry Karstens, his wife Louise, and son Eugene. At the suggestion of his old friend Charles Sheldon, Harry Karstens was appointed as the first permanent Park Superintendent in 1921. He established the first park headquarters in Nenana where his wife, Louise, was a nurse in the Railroad hospital. The Karstens and their son Eugene moved to the new Park Headquarters when it was completed in 1924.

I shall never forget that when he got through asking questions, he said, "You're lacking in experience, but I think you can learn. I'll send you on a patrol trip alone. You will be gone a week. If you don't get back by then, I'll come looking for you, and you had better have plans made for a new job. Now this is what I want you to do." He then outlined a week's patrol trip cross country through territory new to me. There were no blazed trails to follow.... No reliable maps of the Park were available in those days.

Grant Pearson describing his 'interview' for his ranger job with Superintendent Harry Karstens in 1926.

My Life of High Adventure, 1962

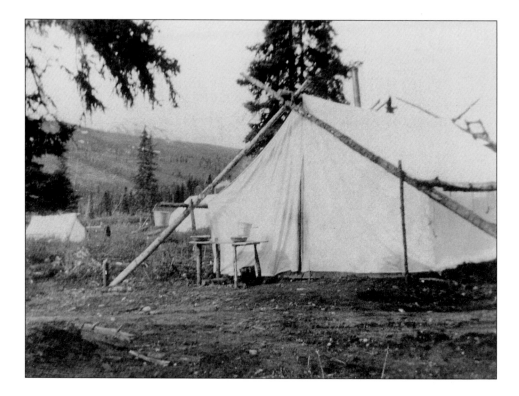

We are practically sure of having the twelve miles from the Railroad to Savage River where the first camp will be located open for light automobile traffic by the first of August.... It will be possible however, for a reasonable number of visitors to motor out twelve miles to a comfortable camp and to go as much further on foot or on horseback as they may desire. Morino is fixing up his roadhouse and the local camping company contemplates some additional accommodations.
Arno Cammerer, Acting Director of the Park Service
May 23, 1924

Above: Wall tents were made of canvas and had wooden frames. The Denali Park road was pushed through to accommodate the expected flow of visitors to the park. The road construction workers lived in tent camps.

Opposite Top: The Alaska Road Commission Camp at 12 mile, near Savage River. University of Alaska student Herbert Heller took many of these photos working for the Road Commission during the summer of 1929.

Opposite Bottom: Primitive road graders were used by the Alaska Road Commission to build the Park Road under the supervision of the National Park Service.

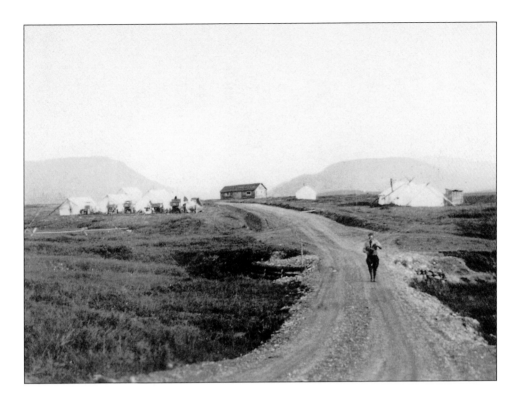

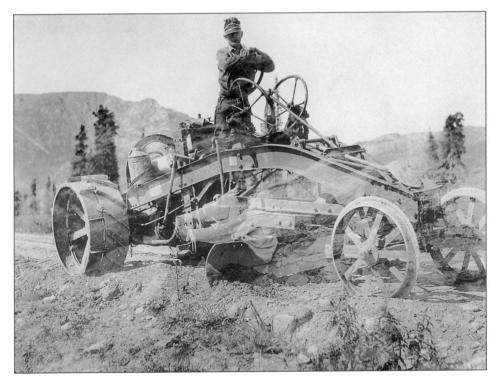

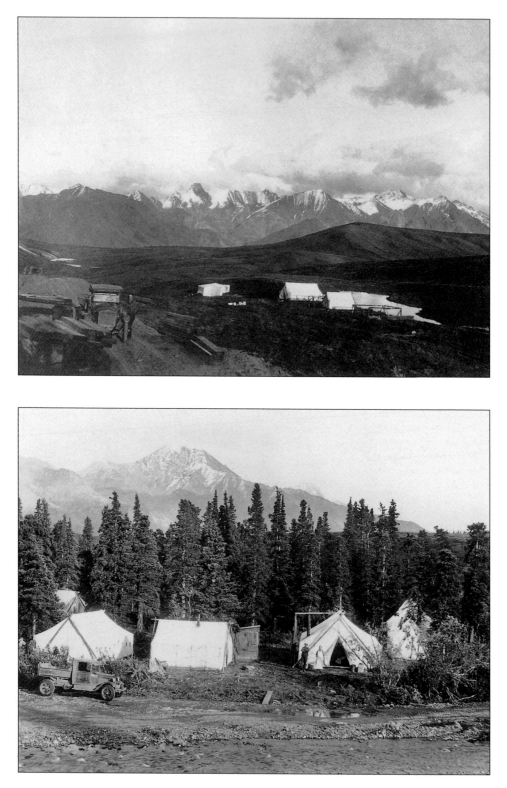

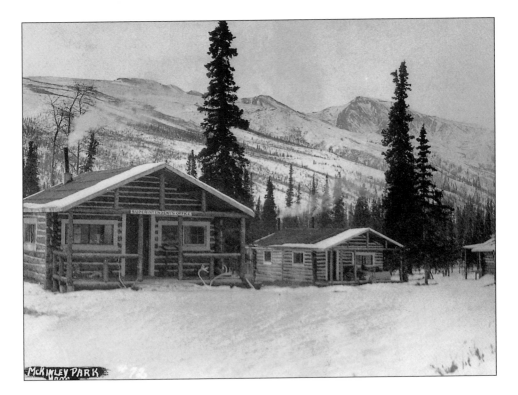

MCKINLEY PARK

Opposite Top: Alaska Road Commission workers established tent camps along the road as work progressed through the park. This is the A.R.C. camp at Six Mile, in 1929.

Opposite Bottom: A.R.C. Camp at Sable Pass.

Above: Superintendent's Office, Park Headquarters. This original superintendent's office is still standing, one of the oldest buildings in the Park Headquarters historic district, although it was moved in 1950 to a new site.

A fair stand of spruce timber was located within a mile of headquarters, and logs were cut, and the timber hauled to the headquarters site before construction work was begun. A 6-6 cellar was dug by hand, and the work proceeded according to schedule until funds for sawed lumber and other purchased materials were cut a month later. The ever resourceful Karstens salvaged windows, a door, and lumber for the roof and interior finish work from the railroad construction. Superintendents Reports, 1926

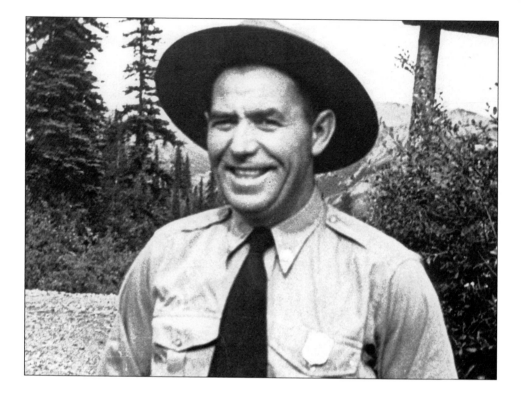

Tremendous changes, still below the surface were about to take place. When the Alaska Highway had been opened to tourists, they had immediately rolled up a great demand to be able to drive to McKinley; a 160-mile gravel road, dubbed the Denali Highway, was now being built. Other tourists were flying in from the states. I put in large camp grounds with modern plumbing at Savage River, Teklanika, and Wonder Lake, and set up a park museum at headquarters. I laid plans for a tourist center and observation building at Eielson, with broad picture windows looking out at the mountain. We built four modern ranger residences at headquarters...hooked up to new electrical, water, and sewer systems. I got the notion of telling Alaska people themselves about their park, gathered together films on mountain climbing, wildlife management and conservation.

Grant Pearson, My Life of High Adventure, 1962

Above: Grant Pearson was hired as a beginning ranger in 1926 by Park Superintendent Harry Karstens, a pioneer of the area, beginning a twenty-five year career with the park service. Pearson climbed McKinley twice, and served at Yosemite, Katmai and Sitka, and was appointed Superintendent himself in 1949. After retiring from the park, Pearson was elected to the first Alaska State Legislature in 1959.

Opposite Top: Road officials visiting the Little Annie mine.

Opposite Bottom: The Mt. McKinley Tourist and Transportation Company used their open touring cars to bring guests to their Savage River Camp.

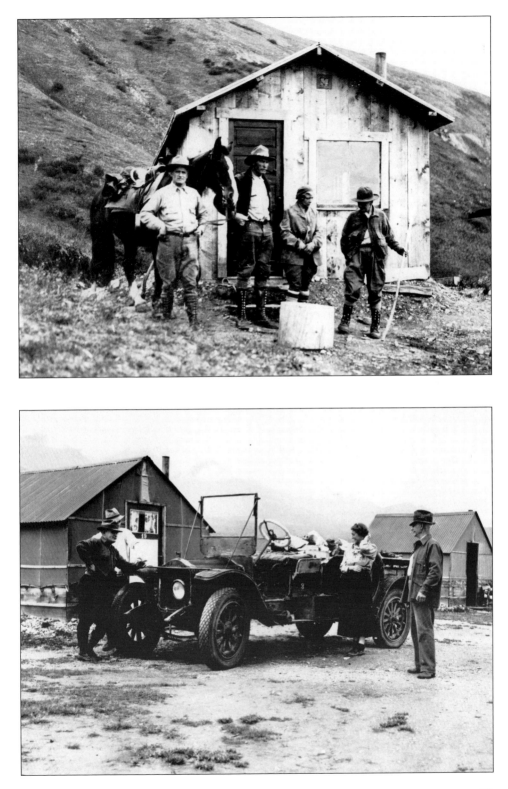

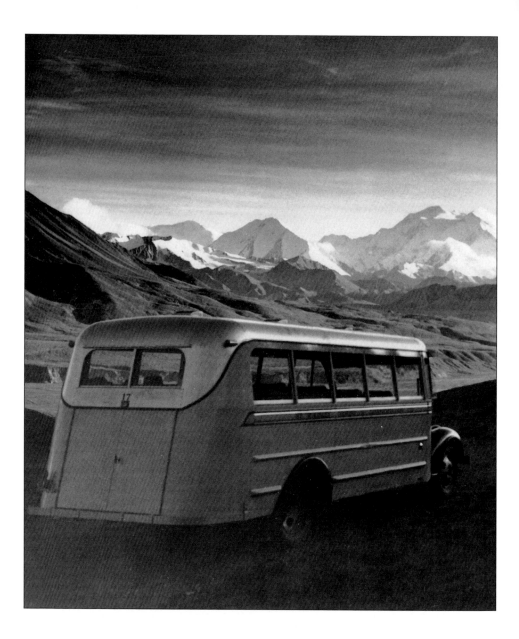

That the purpose of the proposed National Park Service is to conserve the scenery and the natural and historic objects and the wild life therein and to provide for the enjoyment of the same in such a manner and by such means as will leave them unimpaired for the enjoyment of future generations. National Parks Act signed by President Woodrow Wilson on August 25, 1916.

Above: By 1926, the Mt. McKinley Tourist and Transportation Company had a fleet including 9 vehicles and 30 saddle and pack horses, as well as two stage coaches, used previously at Yellowstone Park. In 1927 they added a 14-passenger bus.

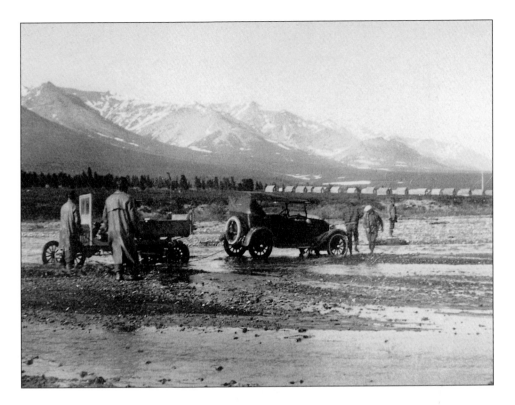

Above: Fording one of the parks' many rivers. Conditions were still rough for the early touring cars.

Pages 76 and 77: College boys showing off at Eielson Visitors Center in a publicity photo from the 1950s.

From numerous places on the flats, slopes, and crests, Denali in all its magnificence and imposing grandeur reared its massive snowy bulk toward the sky, looming apparently very near although really 70 miles away. It ever dominated the landscape, glorifying that mountain world. So strong and deep were the impressions it produced on me that my journal was almost daily filled with records of the joy of beholding it. The vision can never fade, and the ecstasies produced by such long intimacy with it will linger vividly throughout my life.
Charles Sheldon, August 20-21, 1906

THE ALASKA RAILROAD

In 1912, a bill creating an Alaska Railroad Commission was tacked onto a second Organic Act, giving Alaska its own legislature. The commission was to investigate and report to Washington on the best routes.

Their report recommended extending the existing Copper River and Northwestern lines from the terminus in Chitna into the Tanana Valley and on to Fairbanks. The commissioners recommended a second line from the ice-free port of Seward to the Matanuska coal fields, up the Susitna Valley, to Fairbanks. This combination would tap the principal coal and potential agricultural areas, and curve close to the boundaries of the proposed park.

Congress finally authorized the railroad in 1914, leaving the choice of route up to President Wilson. Believing it would be unpopular to purchase and extend the Guggenheims' Copper River Railroad, Wilson chose the 400-mile Susitna route in April 1915. Survey and construction began almost at once, and created a boom in Alaska, employing as many as 4,500 men. Anchorage, an Athabascan fish-camp site which had previously had only three white families living there, suddenly became a teeming construction site, headquarters of the Alaska Engineering Commission. Nenana, with good river access to the Yukon via the Tanana, was chosen as the Alaska Engineering Commission's northern headquarters.

The railroad through the wilderness was finally completed in the summer of 1923, nine years after its authorization. President Warren Harding drove the Golden Spike at Nenana on July 15, 1923.

Florence Harding arrived with her husband President Warren Harding to dedicate the new railroad. Harding died of food poisoning on the way home to Washington from this trip.

79

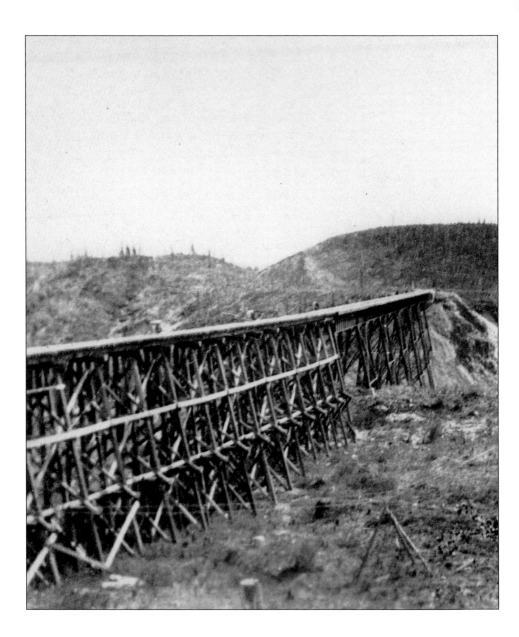

Above: Much of the railroad was constructed using wooden trestles.

In a short time, the railroad will be constructed close to it [the park]; and during construction thousands of head of game will be slaughtered for meat [by] those constructing the railroad. Charles Sheldon, Remarks at National Parks Conference, 1914

Opposite Top: The Riley Creek Bridge was one of the major construction efforts in the park area.

Opposite Bottom: Crane at work at Nenana on the Alaska Railroad.

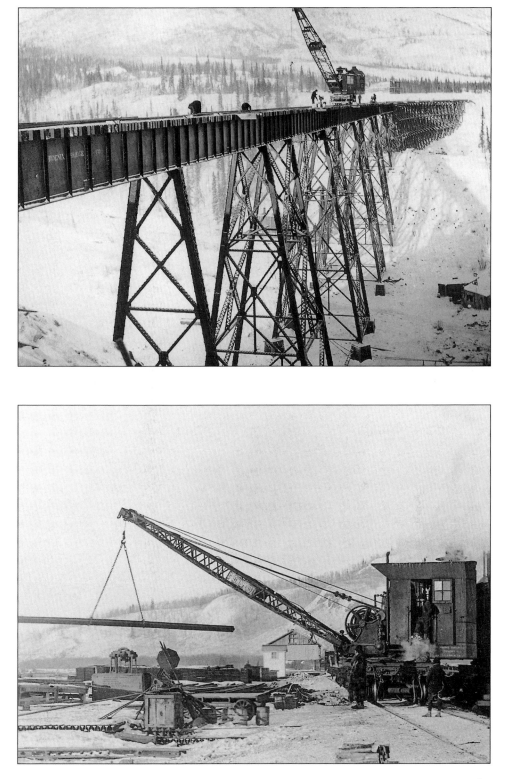

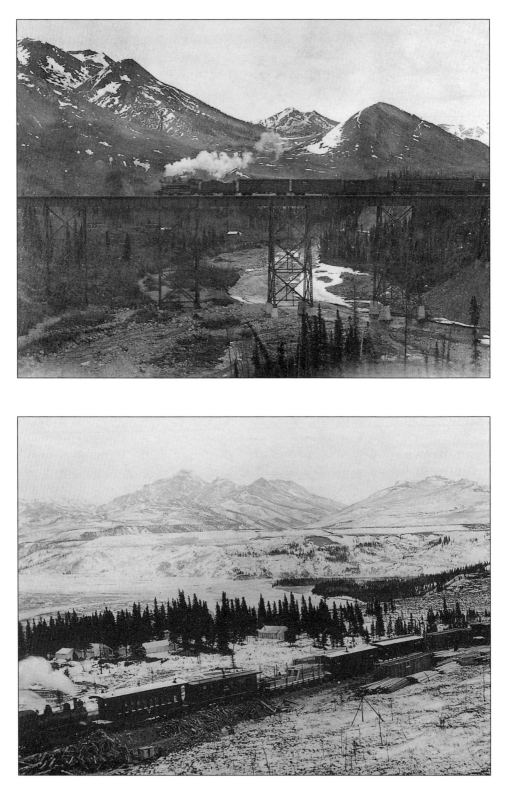

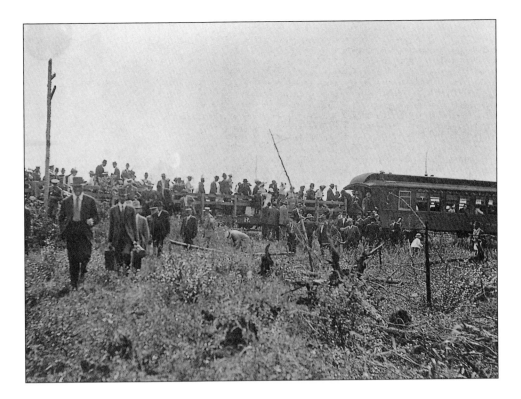

Opposite Top: The Alaska Railroad Riley Creek Bridge, looking downstream on Riley Creek. The original McKinley Park Station community, including Morino's original roadhouse, was in the area called "the Hole" under the bridge, on the north side of Riley Creek. By the time the trestle was completed in 1922, there was also a large A.E.C. camp upstream from the bridge on the south side of the creek. Both communities were later abandoned.

Opposite Bottom: "Camp at end of steel," consists of a work train in Broad Pass.

Above: Although Mt. McKinley National Park was established in 1917, and had a superintendent by 1921, the official dedication of the Park did not take place until 1923. At the invitation of the

Secretary of the Interior, the Brooklyn Daily Eagle, whose owner was a long-time supporter of the parks, organized a party of 70 to travel to the park for the official dedication. Plans were made to transport the party to Savage River where ceremonies were to be held, but because of "the difficulties of the trip," the Dedication Ceremony was held at the entrance to the park when the visitors arrived. July 9, 1923.

Pages 84 and 85: The new Alaska railroad crossing the dramatic Riley Creek Bridge, just south of the park entrance.

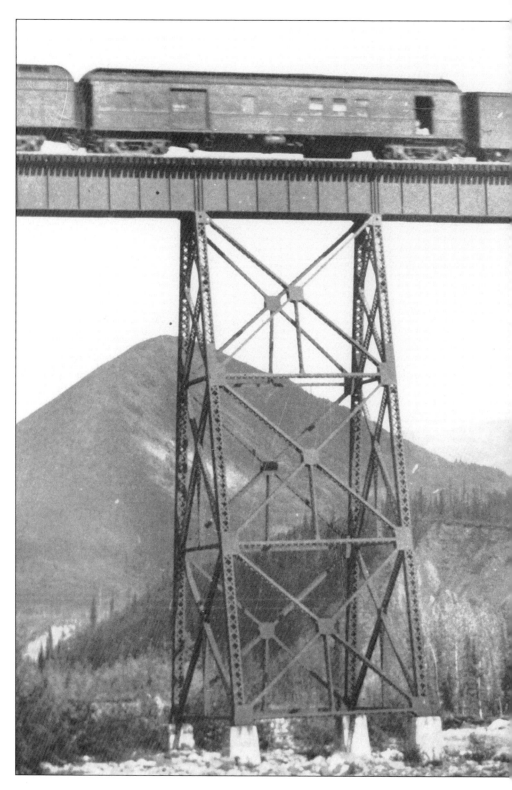

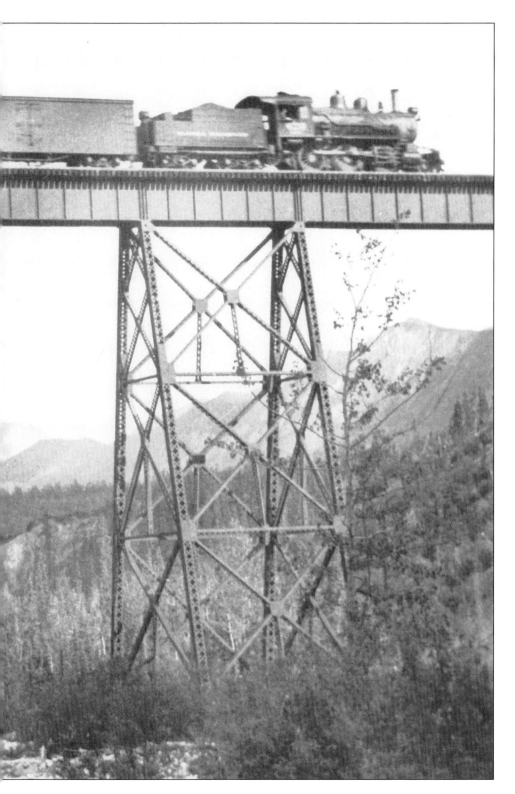

AT HOME IN THE WILDERNESS

The original park boundaries were drawn to exclude areas that were being used, or were inhabited by miners, homesteaders, and traders. The park neighbors were concentrated at the eastern end of the park near McKinley Park Station, and at the western end in the mining district of Kantishna. These areas have now been incorporated into Denali National Park and Preserve, and the reminders of their earlier inhabitants are part of the cultural heritage of the park.

In the early days, the Park Service and its personnel, like all residents of remote areas, depended on the goodwill and experience of its neighbors. At McKinley Park Station, Maurice Morino's trading post and roadhouse provided lodging for park tourists and construction workers on the Park Road as well as services like a post office. At the western end of the park, miner Fannie McKenzie Quigley became as much of a park attraction as the sheep and caribou. Fannie and some of the other early miners taught many early rangers such as Grant Pearson valuable wilderness survival skills.

The town of Kantishna was first established during the gold rush of 1905-6. Sometimes known as Eureka or Shamrock City, it had a renaissance during the mining excitements of 1919-21. The Kantishna Roadhouse occupies the site today.

Farther out in the Denali Preserve, Native and white trappers occupied homesites and ran trap lines on the Kantishna and Bearpaw Rivers and near Lake Minchumina.

Tourists of the 1960s enjoy a classic view of Mt. McKinley. Visitors were able to drive their cars into the park via the Denali Highway after its completion in 1957.

John and Polly Anderson once occupied perhaps the most-photographed spot in the park—the north end of Wonder Lake. They tried various schemes to make a living there, including a roadhouse, fox farm, and damming the lake outflow in order to mine Moose Creek. Today the site of their colorful home is wilderness once again.

Above: USGS geologist Stephen Capps made a complete geological survey of the Kantishna in 1916.

Opposite Top: Joe Quigley, Joe Sway, Miss Lindstrom, Miss Ryan, and Nels Henderson, who for years hauled supplies to the Kantishna diggings, with his gas powered boat.

Opposite Bottom: Italian immigrant Maurice Morino homesteaded a flat bench overlooking Hines and Riley Creeks and built a roadhouse hoping to capitalize on the construction of the Alaska Railroad.

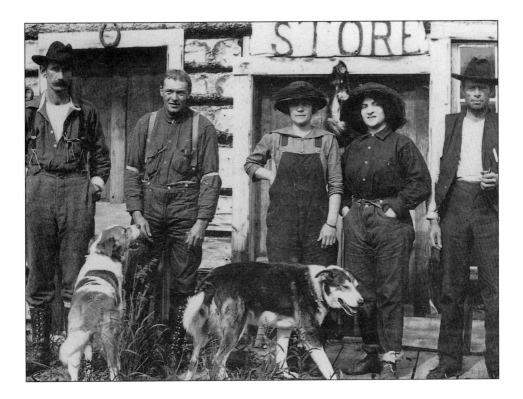

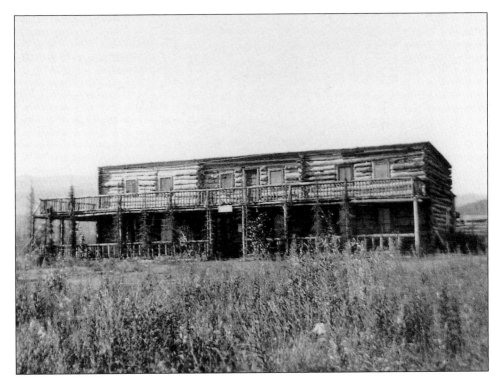

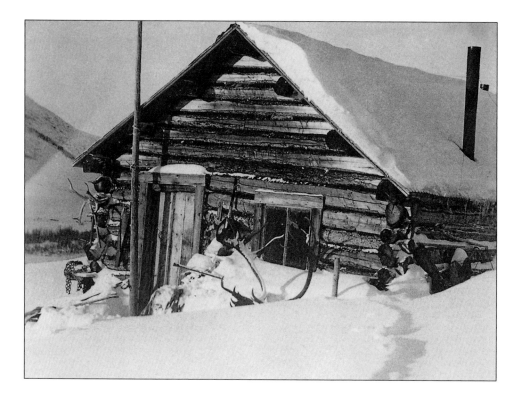

One of Alaska's most colorful Pioneers came to the end of her tread last week when Fannie Quigley died quietly and alone in her little house in the Kantishna where hundreds of park visitors, explorers, scientists, trappers, and prospectors had visited her in the past 30-odd years since she settled there at the edge of McKinley National Park, a hundred miles from the railroad.

In the Kantishna, Fannie became a legend. Her abilities to work like a man, hunt, kill, skin, butcher pack and cache her own game, embroider like an artist, and entertain like a queen, spread her fame in books and stories and brought many visitors to her place in the shadow of Mt. McKinley to see and talk with the little woman who stood hardly five feet tall in her rough men's clothes.
Fannie Quigley's Obituary, Fairbanks Daily News Miner, August 28, 1944

Above: Fannie's cabin in the snow.

Opposite Top: Fannie McKenzie Quigley hiking with her dogs.

Opposite Bottom: Interior of Moose Creek cabin #2.

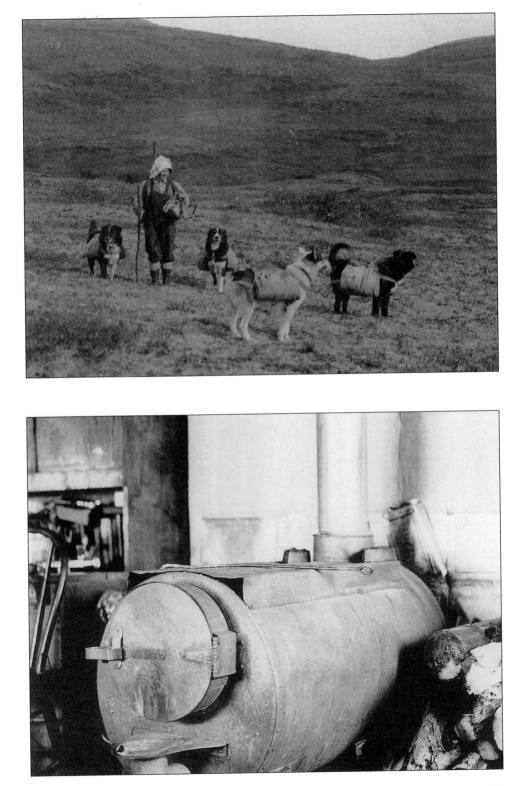

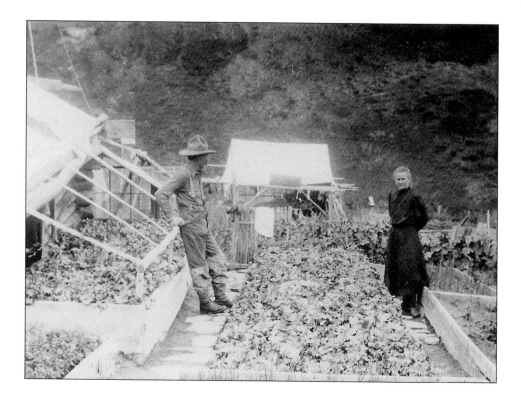

On a bench at Quigley's cabin an area 40 feet above the creek has been worked. Spruce grows up to Claim 6. At No. 14, Elevation 1900 feet, this year by Aug. 1 in Fannie McKenzie's garden cauliflower was matured, cabbages well grown, but barely beginning to head, lettuce in great heads, radishes over mature, onions mature, new potatoes 2 1/2 inches in diameter. This season is unusually late. Rhubarb, rutabagas, cucumbers grow well. Certain varieties of tomato ripen. Volunteer timothy matures in July. Corn was well filled in their ear at fish camp by early July. Oats ripen well. Blueberries come in ordinarily July 1 to 10, but about Aug. 1st this year. Cranberries grow profusely in places. Raspberries will ripen July 10 to August 1st. Five big strawberry plants in garden, but no berries (plants second year). Gardens of flowers (poppies of several varieties) bloom in late July. Pansies and many beautiful wild flowers of wide variety including wild yellow poppies. Potatoes are varied in quantity and they and lettuce, cabbage, cauliflower, turnips, rutabagas, and fine celery can be stored for winter use. Blueberries can be gathered in large quantities.
Stephen Capps, Journals, Summer 1916

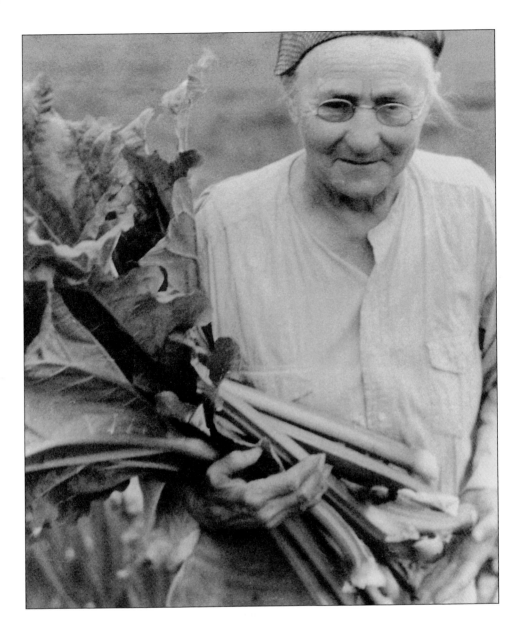

Opposite: The Quigley garden at Glacier Creek.

Above: Fannie Quigley with rhubarb.

Pages 94 and 95: The village and trading site of Nenana was chosen as the northern headquarters for railroad construction. The new townsite was laid out by the engineering commission, and a town lot sale held in 1916. The railroad built shops, offices, housing and a hospital. Between 1919 and 1922, Nenana grew larger than Fairbanks, and even had its own newspaper.

WATER FRONT, LOOKING
UP THE TANANA RIVER

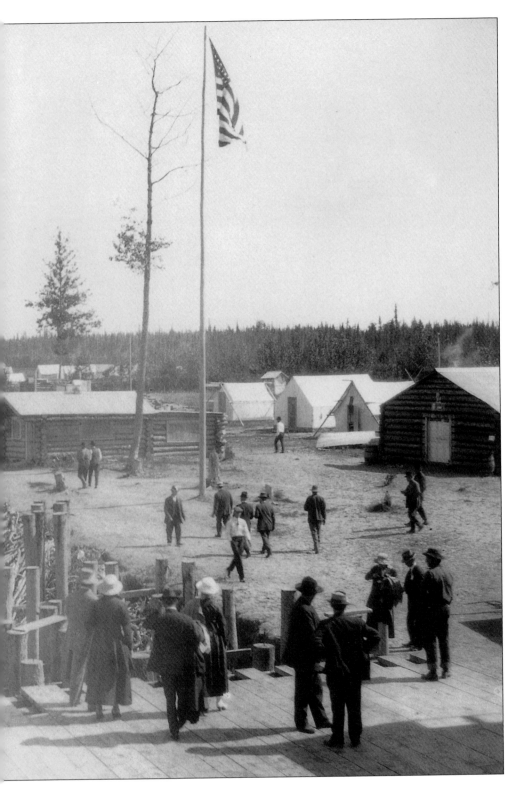

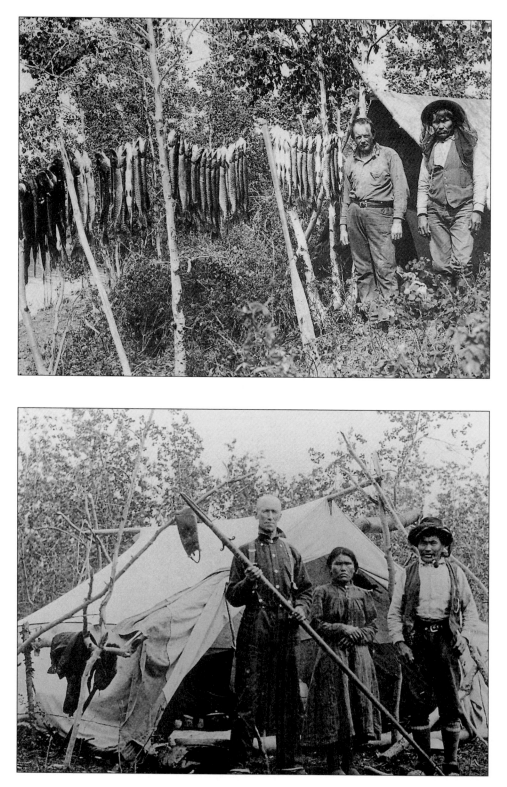

Opposite Top: Stephen Foster was a trapper, big game guide, and game warden, but he is remembered for his hundreds of photographs of the people of the Kantishna, Nenana, and Lake Minchumina area between 1913 and 1922. He is pictured here with his Native guide and friend, Andrew, at Lake Minchumina.

Opposite Bottom: Walter Ames, a white trapper, holding an Indian bear spear at Lake Minchumina in 1916.

As prices for furs peaked, many men who had come into the country as prospectors turned their hands to trapping. Thirty or forty non-native men trapped in the Kantishna-Lake Minchumina area. In 1920 the world-wide influenza epidemic reached the Interior and tragically killed as many as 75% of the Native people in the small camps and villages. Families were decimated and traditional hunting and fishing and trapping patterns disrupted. The white trappers fared better, and took over many of the trap lines. Mostly bachelors, they gradually faded out of the country when fur prices plunged during the Depression.

Above: Miss Lindstrom and Miss Ryan hamming it up with Joe Dalton on a pleasure trip to the Kantishna.

I tramped ahead of the pack train over ground covered with the luxurious and magnificent flora of the region, then in full bloom, Arctic terns, and flocks of Hudsonian curlews flew about; ptarmigan with young continually flushed; flocks of migrating robins passed overhead, and golden eagles soared high and low in the landscape. The chatter of ground squirrels was everywhere heard.
Charles Sheldon, Wilderness of Denali, 1930

Above: Fannie McKenzie Quigley's sled dogs.

Opposite Top: Tourists watch a Park Service dog demonstration.

Opposite Bottom: Pioneer musher Harry Karstens introduced dog sled patrols in the park after he was appointed as the first Park Superintendent.

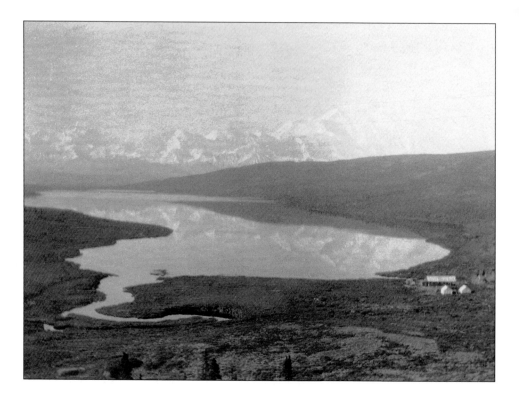

Above: John and Paula Anderson had a Fox Farm and roadhouse at the North end of Wonder Lake. They had come into the country in 1918, from the south, over Anderson's Pass (named after Pete Anderson, McKinley pioneer, and no relation), in 1918, traveling by dog-team in the winter. They tried gold-mining, and trapping and then in 1922 staked their 160-acre homestead, when the trail to Kantishna was completed through the park. This area was at the time just outside the park boundaries. Their roadhouse became a popular stopping place for travelers, and the mining community at Kantishna. The Andersons were keen observers of the wildlife. Joseph Dixon, who studied the wildlife in the Park in the '20s relied on the Anderson's observations of the day, and the hour of the arrival of the different species of birds.

Opposite Top: The Andersons' cabin had remarkable handmade furniture. Grant Pearson, a Park Superintendent, wrote "Chairs, table legs, lamps and chandeliers were all made of clear-varnished, fitted caribou antlers. Even the shelving was embellished with them."

Opposite Bottom: Polly Anderson at a tent cabin with her horse. She was the first woman to cross the Alaska Range via Anderson's Pass.

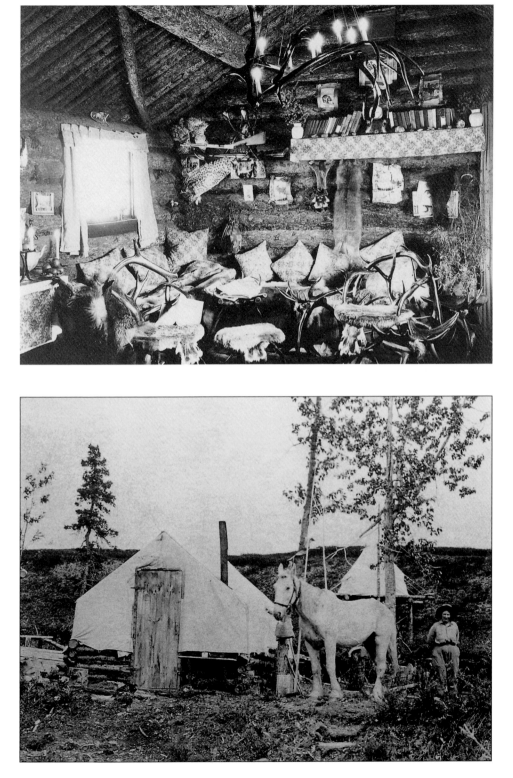

The month of October gave me my first experience of the approach of the northern winter. No impressions seem so closely associated with remote wildernesses or linger so vividly in the memory, as those of characteristic sounds. In the summer the commonest and most vivid sounds are the chatter of ground squirrels, the whistle of marmots, the songs of tree sparrows, thrushes, and other small birds, the croak of ravens, the murmur or roar of the river rapids, and the moaning of the sweeping currents; while in October are heard the joyful notes of the redpolls and the plaintive song of the pine grosbeaks...passing through on their way south.
Charles Sheldon, Wilderness of Denali, 1930

Above: The Hanson Brothers, John, Einar and Emil Hanson, trapped the Kantishna River near the old mining town of Roosevelt from 1916-1950.

Opposite: Joe Quigley, probably the best prospector in the area, soon found a number of lead, zinc, silver, gold, and copper-bearing veins on Mineral Ridge (now Quigley Ridge).

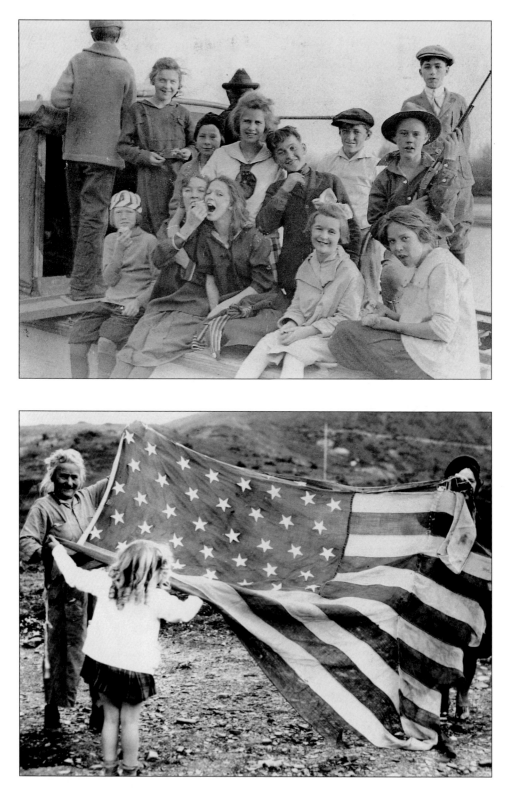

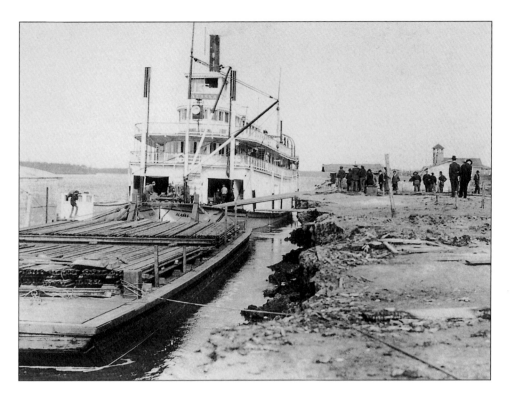

Opposite Top: Nenana school
children.

Opposite Bottom: Fannie Quigley,
with flag.

Above: Riverboat at Nenana with
supplies for the railroad.

'It don't seem natural,' said one, in speaking of the matter. 'It's
too tame like. You ride almost to the diggings in upholstered
seats on a steamer, and find petticoats all along the line. I
kept looking for the telegraph line, and it was hard to realize
that I was on a real stampede, such as we used to follow in
the old days. I suppose electric cars will soon be whirring up
the canyon.'
Fairbanks Daily News, August 1905

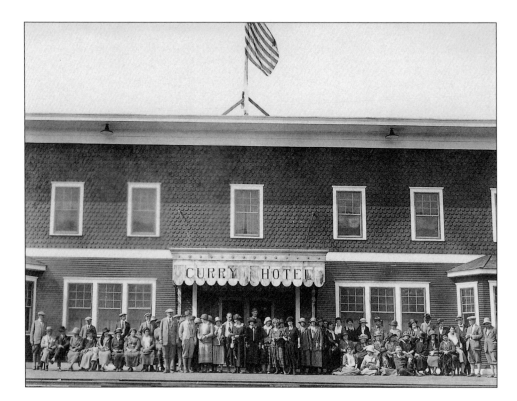

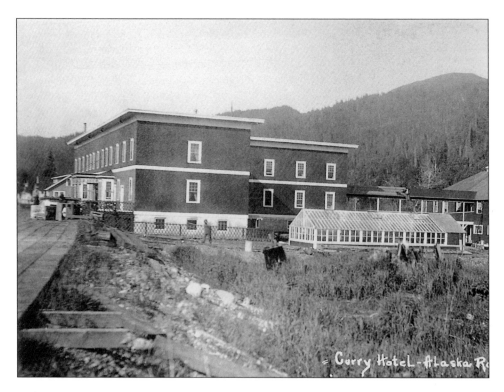

Curry Hotel - Alaska R

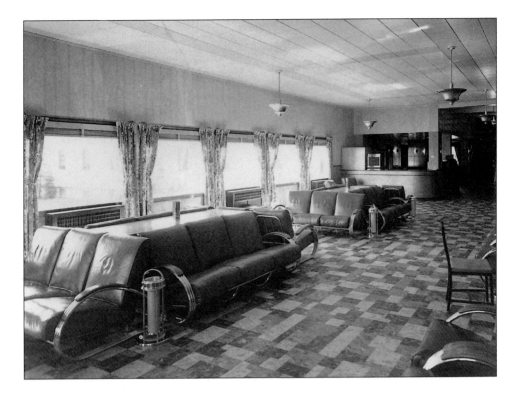

Opposite Top: The Railroad constructed the original Curry Hotel as an overnight stop for railroad passengers. Following the completion of the McKinley Park Hotel, the Curry Hotel was abandoned.

Opposite Bottom: Curry Hotel.

Above: The lobby of the McKinley Park Hotel in the 1930's. Had the new Park Hotel been a purely Park Service effort, it would have been completed in the rustic style already established at park headquarters, and throughout other parks such as Yellowstone, Zion and Glacier. Begun as a Railroad Hotel, however, it took on the utilitarian Railroad style which dismayed park officials.

Mt. McKinley National Park will always be unique and in a class by itself. It will never be over-run with the hordes of automobiles of the campers that are beginning to detract from the enjoyment of many of the other great national parks. Although the number of its visitors will increase annually as its fame spreads abroad, its isolation will always prevent it from becoming the Mecca of the jitney fleets and the crowds of summer campers, and will preserve it for the true lovers of nature and those who appreciate the primitive.
George Lingo, Farthest North Collegian, Vol.VII #3, June 1929, University of Alaska, Fairbanks.

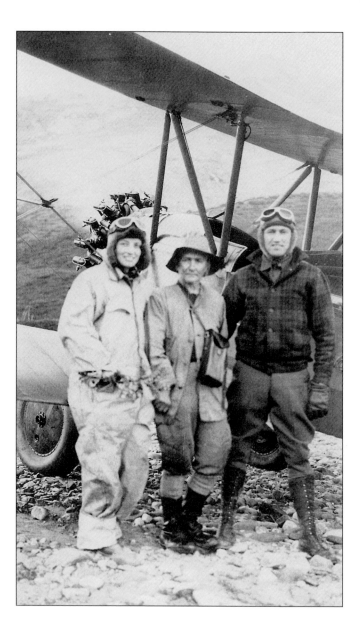

Above: After years of walking or mushing into her claims in Kantishna, Fannie Quigley (at center) landed at Moose Creek with pilot Joe Crosson and his wife.

KANTISHNA RIVER, ALASKA.
FROM AN AIRPLANE.

Above: The Kantishna River from an airplane.

Page 110: Adolph Murie was an early wildlife biologist in the Park.

Page 112: Glorious, radiant, indescribable, stunning, magical!

May 18, 1903 Our craft chugged along all night and when we turned out this morning at six o'clock we were delighted to find we were in a lake-like expanse of quiet water five or six hundred feet wide, and apparently quite deep. We are making good speed. We have remained in these beautiful lakes all day. They are connected by short but rapid and narrow streams and the river stretches out in the general direction of Mt. McKinley. There is no ice left in the stream; much on the low banks, but the current cleared yesterday. The Kantishna is as large as the Wabash, the Sacramento, or the Illinois. The valley is wide and level.

The Kantishna is yet in the valley of the Tanana: its shores are well timbered and fertile. It is a beautiful virgin country, and our boat is the first to enter its waters. It is a glorious spring day; birds sing in the birch and spruce forests along the river banks; innumerable water fowl—ducks, geese, and swan are in the sky. Far across the evergreen valley ahead of us the distant summits of the snowy range sparkle in the sunshine. The landscape nearby bears no resemblance to an Arctic land; it more nearly resembles a scene in the lower valley of the Mississippi.

James Wickersham, Old Yukon, 1938

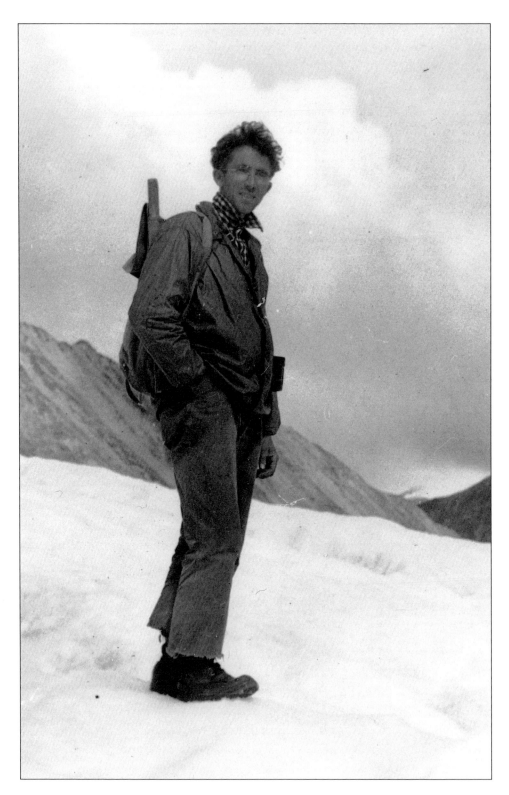

Photograph Credits

This book is largely the result of the excellent care and preservation of photographs in collections at the Alaska and Polar Regions Department, University of Alaska Fairbanks.

About the Author

Jane Haigh has repeatedly visited Denali since her first trip in 1973. She is interested in both the landscape and people who have called Denali home. Jane lives in Fairbanks with her husband and two daughters. Her other work includes *Gold Rush Women*, *Children of the Gold Rush*, and *Catch and Release: the Insiders Guide to Alaska Men*.

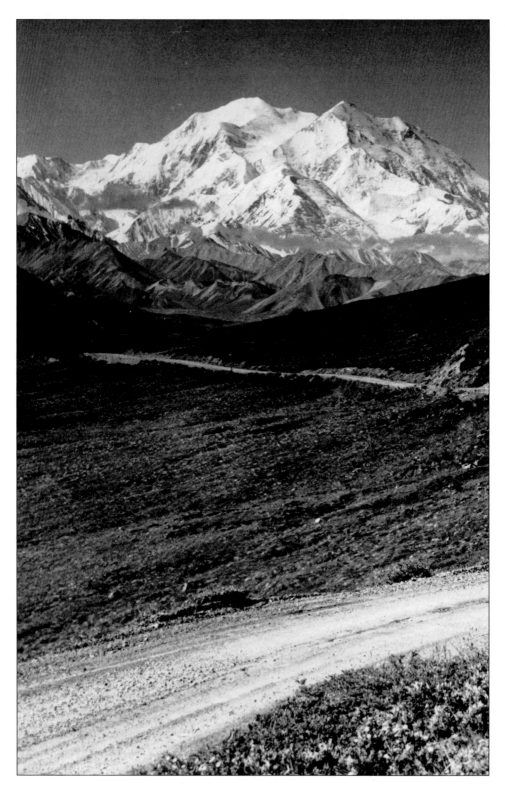